Understanding
RAW
Photography

THE EXPANDED GUIDE

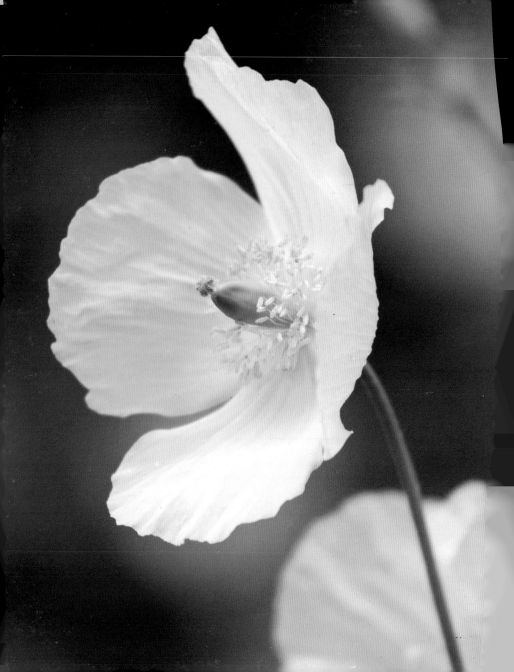

Understanding
RAW
Photography

THE EXPANDED GUIDE

David Taylor

AMMONITE
PRESS

First published 2012 by
Ammonite Press
an imprint of AE Publications Ltd
166 High Street, Lewes, East Sussex, BN7 1XU, United Kingdom

Text © AE Publications Ltd, 2012
Illustrative photography © David Taylor, 2012 (except where indicated)
Copyright © in the work AE Publications Ltd, 2012

ISBN 978-1-90770-855-8

The publishers and author can accept no legal responsibility for any
consequences arising from the application of information, advice or
instructions given in this publication.

A catalog record for this book is available from the British Library.

Editor: Chris Gatcum
Series Editor: Richard Wiles
Design: Richard Dewing Associates

Typeset in Frutiger
Color reproduction by GMC Reprographics
Printed and bound in China by Hing Yip Printing Co. Ltd

(Page 2)
A Californian Poppy in an
English country garden.

CONTENTS

Understanding RAW photography

Using RAW files is often viewed as something that is only for professional photographers, but this is far from the truth: shooting and then processing RAW files is for *anyone* who wants to make the most of their photographs.

In normal usage, the word "raw" is a synonym of uncooked, unrefined, and unprepared. This is a very apt description of what camera RAW files are and is the reason for this name. A RAW file is a package of the image data captured by the camera sensor when you press the shutter-release button to make an exposure. The camera does not process this image in any way so, unlike a JPEG file, it has not been "baked."

This makes viewing RAW images initially disappointing, as they often appear flat and washed out, compared to a JPEG that can look perfect straight from the camera. What

the RAW image has, however, is potential. That is what this book is about: how to realize the *potential* buried in your RAW files.

If you come to this book having only ever shot JPEG there are a few habits that may need to be unlearned, since shooting RAW requires a different way of working. You will find out how to think "RAW" in the following pages and, as you will see, there is nothing difficult about shooting RAW files. Indeed, when mastered it is a very creative and fulfilling way of working, and once you start you may never shoot JPEGs again!

PICTURE STYLE
Whatever your favorite photographic subjects are, using RAW will help you to extract the full potential from your images.

Canon 1Ds MkII with 70–200mm lens (at 75mm), 1/30 sec. at f/14, ISO 100

PORTRAIT *(Opposite)*
Canon EOS 7D with 70–200mm lens (at 175mm), 1/100 sec. at f/4, ISO 100

Life in the RAW

Using RAW files isn't the easy option. RAW files cannot be used straight from the camera: they require a commitment of time in post-production to make the most of their potential. So why use RAW?

The JPEG option

All digital cameras have the ability to record a type of image file called a JPEG. The name derives from the Joint Photographic Experts Group who formulated the standard in 1992.

Most people start their photographic career by shooting using JPEG, which is understandable, since a JPEG is the digital equivalent of a film transparency or slide. What I mean by this is a JPEG is essentially a finished image that is ready to be added to a word processing document, printed, or uploaded to the web straight from a camera.

RAW files, on the other hand, cannot be used straight from a camera—they need to be processed by the photographer and converted to a more usable file type. This requires a certain amount of effort and it is all too easy to spend more time optimizing and converting RAW files on your computer than taking new photographs. However, the problem with using JPEG is that a whole world of creativity is taken away from you.

Just how you like it

Even if you think you've only ever shot JPEGs, you have actually used RAW. The reason for this is your camera *always* captures the RAW data at the moment of exposure, and a JPEG is created from this using a variety of settings (sharpness, contrast, and so on) that are set automatically by the camera or by you.

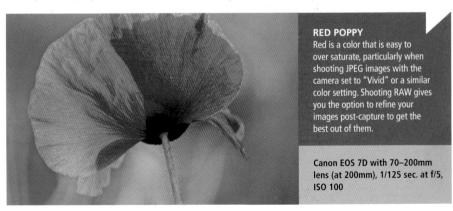

RED POPPY
Red is a color that is easy to over saturate, particularly when shooting JPEG images with the camera set to "Vivid" or a similar color setting. Shooting RAW gives you the option to refine your images post-capture to get the best out of them.

Canon EOS 7D with 70–200mm lens (at 200mm), 1/125 sec. at f/5, ISO 100

Regardless of how much control you have over your camera's JPEG settings, once they have been applied, they are essentially "fixed." After processing, the JPEG is saved to your camera's memory card and the RAW information is discarded.

Using RAW files leaves this processing stage entirely to you, allowing you to decide how much or how little processing will be applied to the image. Think of it this way: if a JPEG is a cake, then a RAW file is the ingredients. If you need a cake immediately, JPEG is ideal, but if *you* want to decide what sort of cake you would like to make then RAW is what you need to be shooting.

Compression

A further feature of shooting JPEGs is that the files take up far less space on the memory card than an equivalent RAW file. This is because a JPEG is compressed to reduce its file size. This

may sound like a good thing (you can fit more images onto your memory card or hard drive), but there is a price to pay: a JPEG is compressed by discarding fine image detail, and the greater the level of compression, the greater the loss of detail. More importantly, once this detail has been lost it is gone for good.

RAW files are often compressed as well, but the type of compression used does not throw anything away—it is "lossless." This makes the compression less efficient, but it does mean that every detail is there when you process the RAW file. On the downside, using RAW files exclusively does mean that you will need a larger memory card than if you shot JPEGs, and more storage space on your computer's hard drive as well.

COMPRESSION
This is a JPEG image with maximum compression applied. The result is a mess of hard color bands and there is a loss of fine detail.

Camera sensors

A digital camera creates an image when light is focused through a lens onto an active photo-receptive device known as a sensor.

A mosaic of color

A digital imaging chip, or sensor, consists of millions of tiny, light-sensitive photosites, which gather the light coming through the lens. On their own, these photosites record the brightness of the light, not color, so to create color images almost all sensors used in digital cameras today employ what is known as a Bayer filter.

In a Bayer sensor, the photosites are filtered, so in a group of four photosites, one is filtered so it is sensitive to red light, one filtered for blue, and two filtered for green. In a process known as demosaicing, the information from groups of filtered photosites is combined to produce a full-color pixel in the final photograph.

The resolution of the sensor is the number of full-color pixels that it can create, so a sensor that is capable of capturing an image measuring 5,000 x 3,000 pixels (15 million pixels in total) is referred to as a 15 megapixel (or 15MP) sensor.

Catching light

The most common analogy used to describe how each photosite works is that it is like a bucket catching rain, with the rain in this analogy being photons of light passing through the lens. If each photon is thought of as a unit of information, then the more you can capture during the exposure, the more information you have to build up an image.

Compact digital cameras have smaller sensors than those found in digital SLRs, which means that the physical size of the photosites must be reduced in comparison to a digital SLR's in order to squeeze the same number of photosensors on.

DEMOSAICING
Individual pixels in your images are created using filtered photosites—in a grid of four photosites there would be one red, one blue, and two green filters.

Note

Why two green photosites? Well, the human eye is more sensitive to green light than it is to red or blue and by having two green-filtered photosites a digital camera mimics this sensitivity. As a result, the green channel of an image is often far less noisy than the red and the blue channels because more "green" has been captured and more information gathered in this channel.

This reduction in the amount of information captured has an effect on the final image. Typically, images from compact digital cameras display more noise, have less dynamic range, and cannot use as high an ISO as a digital SLR. That is not to say that technology isn't improving, and many modern compact digital cameras can produce astonishingly good images. However, any improvements gained can be applied equally to a larger sensor, so there will always be a disparity.

Units of information

After exposure, the amount and quality of light captured is processed by the camera to produce the image information, which is stored as digital data. In computing, a "bit" is the smallest possible unit of data and, like a switch, it can be set off or on: when a bit is "off" it is set to 0 and when it is "on" it is set to 1.

The next unit up from a bit is a "byte," which is a string of eight bits. Computers use binary notation, so eight bits can be used to store numbers from 0 to 255 (or from 00000000 to 11111111 in binary).

This means that to store image data you could use one byte to create 256 different tones, from no tone (or black) when the byte is set to 0, to maximum (or white) when the byte is set to 255. However, this only refers to grayscale brightness. To display a full-color pixel on a monitor, three bytes are used: one byte is used to represent red, one for blue, and a third for green

COLORS
The Adobe Color Picker palette is a good place to explore the world of color on your computer. In this instance I've picked a pure green, with no red or blue added to the mix.

(hence the initials RGB). This results in 16.7 million different possible color combinations when red, blue, and green are mixed in different proportions (256 red values x 256 green values x 256 blue values).

Bit-depth

Sixteen million colors may seem like a large number, but in reality using one byte (or 8-bits) per color is very limiting. If you make a color adjustment that generates a color value that is a fraction (such as 130.7), that number will need to be rounded up (or down). Do lots of these adjustments and any rounding errors are compounded, which can result in a visual error known as "posterization." This is seen as sudden jumps or gaps between colors in an image.

The solution is to use 12-, 14-, or 16-bits (or two bytes) of information to record the color value in a digital image. In a 16-bit image there are 65,536 levels of color per pixel as opposed to 256, resulting in 281 trillion different color combinations! While computer monitors and printers can't display this range of colors (and we'd also struggle to perceive them all), software such as Adobe Photoshop and Lightroom can make use of this extra information "behind the scenes," making rounding errors far less likely.

As JPEG files are 8-bit only, this is one of the reasons why making adjustments to a JPEG can

quickly result in a loss of image quality. However, the RAW files generated by a digital camera may be 12-, 14-, or even 16-bit, which means there is far more data for making adjustments, without degrading the image quality too drastically.

The drawback with using 16-bit image files is that the file size will be twice as big as an equivalent 8-bit image file. Bigger file sizes again mean more storage space is required on a memory card or hard drive. Another drawback is that most applications, such as web browsers, are only compatible with 8-bit images. For this reason, RAW files are edited in 16-bit for maximum quality and then converted to 8-bit (often JPEG or TIFF file) for general use.

POSTERIZED
The top image was adjusted in 16-bit and the colors have remained true. The image below was edited in 8-bit, resulting in strange color shifts and far less subtle color transitions.

> **Note**
> The term "bit-depth" refers to how many bits are used to record the color values in an image.

How many colors?

A color space is a mathematical model that describes the range of colors an imaging device such as a monitor, printer, and so on, can capture, display, or print. These color spaces are device-specific as different imaging devices have different color spaces. For instance, printers generally have a smaller color space than monitors. In a properly calibrated system, each imaging device attached to a computer would have a profile, which is a file stored on the computer that describes how each device handles color.

Photoshop's default working color space is Adobe RGB, and images imported into Photoshop are tagged automatically with this working space. Adobe RGB is a wider color space than the color space of most imaging devices, but by using the profiles of the monitor and printer, Photoshop is able to translate between the two devices using Adobe RGB as a bridge. Theoretically, this means that the colors you see on your screen will closely match the colors in a print.

Most cameras have an option to select a color space, usually allowing the choice of Adobe RGB or sRGB. Adobe RGB has a larger color space than sRGB, which is why Photoshop uses it as the default working space. When you shoot JPEG images, the color space you have set on your camera will be tagged to the file. If you convert to another color space afterward, some image degradation will occur. RAW files do not have an embedded color space, giving you the flexibility to choose which one to use at the import stage.

GRAPHS
Running ColorSync on a Mac allows you to compare the color spaces installed on the system. Here I'm viewing a monitor color space. The gray wireframe box around it is the Adobe RGB space, which is much larger.

RAW flavors

Unlike JPEG files there is no one RAW "standard." Instead, there are almost as many RAW format types as there are camera manufacturers.

To make matters worse, the standard adopted by a particular manufacturer may gradually change over time as new cameras are developed and the requirements of RAW files are expanded. If you regularly change your camera this will mean that you will need to update your RAW conversion software regularly as well.

Proprietary RAW formats

As a JPEG file is distinguished by the extension .JPG or .JPEG, you would be forgiven for thinking that a RAW file would end with the extension .RAW, but this isn't the case. Each RAW file type has its own particular extension, often derived from a contraction of the camera manufacturer's name or to represent a particular proprietary technology.

Yet while the name may change, all RAW files share a basic data structure. The first section of the RAW file is a "header," which is a short string of information that helps RAW conversion software identify how the data has been saved. Then comes the sensor metadata, which is information such as the size of the sensor used for image capture. Following this is the image metadata where information such as exposure settings and camera/lens data is stored. Next, an image thumbnail is included to allow a quick preview of the RAW file on the camera or on a computer. Finally—and what makes up the bulk of the information in the RAW file—is the image data captured at the time of exposure.

NIKON D5100
In keeping with all of Nikon's digital SLRs, the D5100 uses the .NEF RAW format.

Manufacturer	RAW Suffix	Notes
Adobe	.DNG	Digital Negative (see next page)
Arriflex	.ARI	
Canon	.CR2	
	.CRW	No longer in use
Casio	.BAY	
Epson	.ERF	
Fuji	.RAF	
Hasselblad	.3FR	
Imacon	.FFF	
Kodak	.DCS	Used in Kodak's professional cameras
	.DCR	Digital Camera RAW
	.DRF	Used by Kodak Pro Backs
	.K25	Used by Kodak's DC25 camera
	.KDC	Used by Kodak's DC40 & DC50 cameras
Konica Minolta	.MRW	No longer in use
Leaf	.MOS	
Leica	.RAW	Some Leica cameras also support .DNG
	.RWL	
Logitech	.PXN	
Mamiya	.MEF	
Nikon	.NEF	
	.NRW	Supports Windows Imaging Component
Olympus	.ORF	
Panasonic	.RAW	Similar to RAW format used by Leica
	.RW2	
Pentax	.PEF	
	.PTX	
Phase One	.CAP	
	.IIQ	
	.EIP	A suite of files used by Capture One 4.7
RED	.R3D	
Rawzor	.RWZ	
Samsung	.SRW	
Sigma	.X3F	
Sony	.ARW	Based on the TIFF file format
	.SRF	
	.SR2	

Adobe DNG

In 2004, Adobe, the developer of Photoshop and other creative software, launched the DNG (or Digital Negative) RAW format. This is an open RAW format that can be used by any camera manufacturer or software developer in preference to a proprietary RAW format.

A new model

Adobe's concept for DNG is appealing and, if the format were used universally, RAW files would certainly become more "archival," since one of the basic problems with proprietary RAW files is software support. Should a camera manufacturer cease trading (as has happened with Konica Minolta), support for their particular RAW file format would eventually dwindle to nothing, meaning a photographer may eventually find it impossible to view or edit old RAW files. However, because DNG is an open RAW format, it has a greater chance of surviving, even if Adobe were no longer in a position to support it.

So far, relatively few camera manufacturers have embraced DNG: of the large Japanese camera companies, only Pentax and Ricoh have shown much enthusiasm, although the high-end Leica M9 and Sinar's medium-format camera backs offer DNG files as an option.

Naturally, Adobe has embraced the concept wholeheartedly, and Lightroom offers the option of converting a camera's proprietary RAW files into the DNG format during the import process. A free, standalone DNG converter is also available and the resulting DNG files can then be opened with Photoshop and later versions of Elements through the Adobe Camera Raw plug-in.

Using Adobe DNG Converter 6.4

Adobe's DNG Converter is a simple piece of software with few dialog boxes and is available for both Windows and Mac operating systems. Once it has been downloaded and installed, it sits in the Program Files (Windows) or Applications (Mac) folder ready for use.

To use the software, copy your camera's RAW files to a new folder on your computer

Note

Because Adobe has to update its DNG Converter every time a new camera (and therefore another variation of a proprietary RAW format) is released, there is always a slight delay before that camera is supported. To convert the new camera's RAW files, a new version of the converter (and Adobe Camera Raw) will need to be downloaded when available.

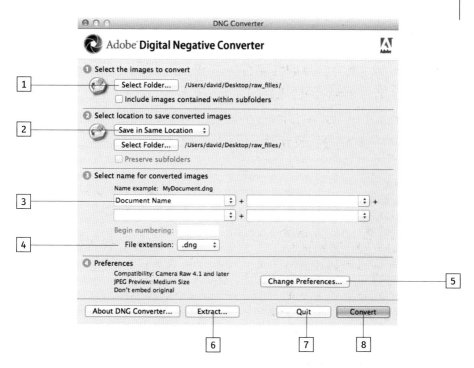

and launch Adobe DNG Converter. Once the conversion process begins (which may take a while depending on the number of files to convert), the software can be left to run in the background until completion.

1 Select the folder you have copied your RAW files to. You can choose whether RAW files in any subfolders are also converted by using the check box below.

2 RAW files can be converted and saved into the original folder, or you can save them into a folder of your choosing. Check *Preserve Subfolders* if you want to retain the same subfolder structure.

3 The DNG files can retain the same file name as the original RAW files, or you can use a different naming convention. Use the pop-up boxes to choose a system, including options for naming your files by date or numerical sequence.

4 As a personal preference, you can also choose whether the .DNG suffix is capitalized or added to the file name in lower case.

5 Change the converter's preferences (as described on the following page).

6 Extract the original RAW file data (as outlined on the next page).

7 Exit without converting the RAW files.

8 Begin the conversion process.

Adobe DNG Converter Preferences

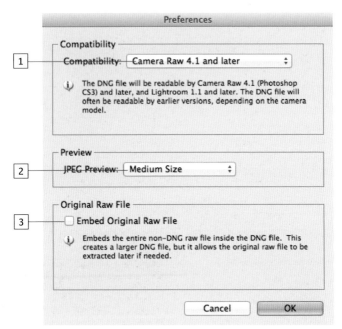

1. Which preferences you choose to set will depend on which version of Photoshop or Lightroom you use. Newer versions of Adobe Camera Raw are not compatible with older versions of Photoshop: for instance, if you are still using Photoshop CS3 you would not want to make the DNG files compatible with Camera Raw 5.0 or later. For maximum compatibility with Photoshop or Lightroom, select *Camera Raw 2.4* or later.

2. This option chooses the size of the thumbnail embedded in the DNG file. This thumbnail is used by your operating system when the DNG file is displayed in a folder. The bigger the preview thumbnail embedded in the DNG file,

the more space it will take up on your computer's hard drive.

3. Nothing is certain in this world, and there is the possibility that the DNG format may not survive. Adobe has therefore given photographers an "opt-out" clause with this option. By selecting *Embed Original Raw File*, all the data from the original RAW file will be included within the DNG. This will obviously make the file larger, but if you have plenty of storage space it will give you peace of mind over the long-term future of your RAW files. Clicking on *Extract* (see previous page) will then recreate the original RAW file from this embedded data.

After conversion

Once the conversion process is complete, your DNG files can be opened in Photoshop through the Adobe Camera Raw plug-in or imported into Lightroom. It is worth noting that Lightroom can also convert your RAW files to DNG automatically during import.

Should you use DNG?

There are some disadvantages to converting your RAW files to DNG. If you intend to use the RAW software that came with your camera, for example, it is more than likely that it will not recognize the DNG files. Also, any camera-specific information that is added to the original raw data, such as a chosen picture style, will be discarded during the conversion process. However, this often makes DNG files smaller than the original RAW file. Finally, converting

your RAW files to DNG means that you are relying on prolonged support for the format— something that cannot be guaranteed. But this is not necessarily any more or less of a risk than relying on continuing support for your camera's proprietary RAW files.

Ultimately, there are promising signs for the DNG format. For a start, Adobe has applied for the format to be recognized as an ISO standard, which is something that is unlikely to happen to any proprietary RAW format and perhaps shows Adobe's commitment to the long-term future of DNG. Indeed, converting RAW files to the DNG format is now part of my workflow, and I discard the original RAW files once this process is complete.

ADOBE LIGHTROOM
Allows you to import RAW files and convert them to DNG in a single process.

Metadata

It is not just the data for the exposed image that is saved in the RAW file—useful information, known as metadata, is embedded there too. Metadata is divided into different categories known as "fields," and the various elements of information in these fields are known as "tags."

Camera information

When you create an image with a digital camera, shooting information metadata, such as the shutter speed and aperture, is saved within the RAW file. This metadata can be read and displayed by imaging software such as Photoshop, and is an excellent way of learning more about your photography. As an example, if you look at the shutter speed field in the metadata, you will begin to get a better idea how different shutter speeds affect the look of your images.

How much information is written to the metadata will depend on your camera: some cameras are relatively terse and only create the bare minimum of metadata, while other cameras embed more information than you'd think would ever be needed. This camera-created metadata is known as Exchangeable Information File Format data or EXIF data for short. It is possible to edit the EXIF data after capture by using specialized software, but it is advisable to leave this information as it is.

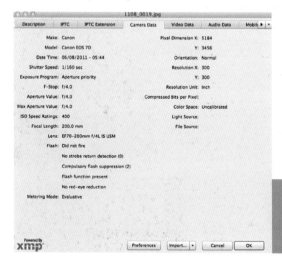

Note
Metadata is also applied to camera-created JPEG files.

CAMERA DATA
This is the EXIF metadata of an image created using a Canon EOS 7D, viewed in Adobe Photoshop CS5.

User information

As well as camera-generated metadata, user-editable information can be embedded in a RAW file, either during the import process or during post-production. This editable metadata can take different forms, but the most common is the International Press Telecommunications Council (or IPTC) format, which was originally developed for photojournalists, but is now widely used by most image-editing software. Both Adobe Photoshop and Lightroom allow you to edit IPTC-standard metadata. The most useful fields in the IPTC metadata are the photographer information fields—your name, address, email, and so on—and the description and keyword fields.

A big problem facing photographers is that of "orphan works." These are images that are available electronically, but for which ownership information has been lost. This means that these images could potentially be used commercially without recompense to the original photographer. Filling in the photographer information fields will help to reduce the risk of this happening to your images.

Some cameras allow you to add your name and copyright information to your RAW files as they are shot, and it is well worth doing this, as it is one less step to think about during the import process. Generally, the copyright in the image belongs to you, the photographer, and therefore the name and copyright fields would be tagged with the same information. However, copyright can be assigned to anyone you like, and if you take photographs for the company you work for, you may find that they insist on owning the image copyright.

USER DATA
The edited metadata of the same image, showing information added to the description and keyword fields.

Contextual information

The description field is just that; a description of the image. It is up to you to decide how the image should be described, but a good rule of thumb is to describe where and when the image was shot, the names of any people in the photograph, and any other information that is relevant and important.

The keyword field should consist of words or short phrases that describe the various elements of your image. A picture of an apple might have the keywords Apple; Fruit; Food; Tasty; Harvest; Healthy Lifestyle; Ripe; Red; Nature; Freshness; Healthy Eating; Green; and Dieting applied to the metadata, for example.

Keywords do not necessarily need to be a literal description of an image; you could also add more conceptual ideas. A semi-colon should separate keywords in the keyword field,

although some software allows you to use a comma as an alternative.

Adding information to the description and keyword fields is important if you plan to use image-cataloging software, or if you supply images to a photo library. Both rely on keywords to enable searches to be made for particular images. If you have ten images it is easy to find the one you want, but if you have ten thousand the task becomes much harder without any keywords to aid the search. For this reason it is important not to include irrelevant keywords into the IPTC metadata since this confuses search results and can make the process frustrating.

COLLECTIONS
To use image-cataloging software such as Phase One's Media Pro effectively requires the use of relevant keyword metadata.

Outside the RAW file

There is one final example of metadata that you will encounter if you use Photoshop and Adobe Camera Raw on a regular basis. So far, all of the metadata we've discussed has been embedded in the RAW file itself. However, when you use Adobe Camera Raw to adjust the settings of a proprietary RAW file, these settings aren't applied directly to the RAW file. Instead, a new file is created in the same location as the RAW.

This new file shares the same name as the RAW file, but has the extension .XMP. The XMP file is essentially a "recipe" of the changes you have made in Adobe Camera Raw and the next time you open the RAW file, Adobe Camera Raw reads the XMP file and re-applies these changes. If you delete the XMP file, Adobe Camera Raw reverts to the settings applied in-camera at the time of exposure.

An XMP file is what is known as a "sidecar" file, storing information that can't be written to the metadata of the main RAW file. If you move or delete your adjusted RAW files to a new location, you will need to make sure the XMP files are also moved or deleted at the same time: Adobe Bridge is intelligent enough to recognize the relationship between a RAW file and its XMP file and will therefore move or delete both together. Lightroom does not create XMP sidecar files; all the changes you make to a RAW file are held in Lightroom's central database.

Why not try?
www.stockphotokeyworder.com suggests useful keywords for images.

XMP
Every change I made to this Canon CR2 file in Adobe Camera Raw was recorded in an XMP sidecar file.

Flexibility

A RAW file is a "digital negative," and how you process it to create the final image is entirely your decision. You can alter the look of the image as little or as much as you like. Although this image was originally in color, I visualized it in black and white at the time of exposure. Shooting RAW gave me the flexibility to refine the image until it matched my original idea.

Camera: Canon EOS 7D
Lens: 17–40mm lens
(at 20mm)
Exposure: 1.6 sec. at f/16
ISO: 100

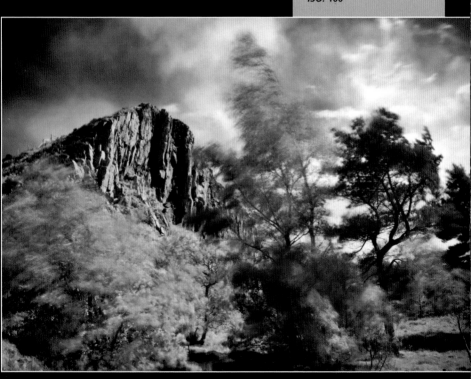

Shot in 2004, this is one of my very first digital images shot in RAW. Because I've converted it from the original RAW file format to DNG I feel more confident that I will be able to open it again if I need to, far into the future.

Camera: Nikon D70
Lens: 70–210mm lens (at 125mm)
Exposure: 14 sec. at f/32
ISO: 200

Accessories

Shooting RAW involves more than owning a camera and a few lenses: the camera is just the first item in a list of equipment necessary to create and process your RAW files.

If everyone were forced to use the same camera, lenses, and computer equipment, the world would be a simpler (and a far more dull) place. However, photographers are assailed by choice, and it is easy to rush into buying equipment, only to later discover you have made a very expensive mistake.

The Internet is a mixed blessing when it comes to helping you decide what equipment you need. There are a lot of very useful online equipment reviews, but also a lot of "white noise" and very partisan debate about the merits of one piece of equipment over another. One of the problems is that choice of equipment is ultimately a personal matter, and a camera that suits one person may not suit another. This isn't just a matter of specifications, but also of more subjective aspects such as handling.

The key is to try before you buy. A good camera store should allow you to handle the equipment you plan to buy, while some may (for a small fee) allow you to use it for a day or so.

Software is somewhat easier to assess as it is often available on a trial basis. Even if this trial is time limited, it should still offer more than enough time for you to evaluate the software and see if it is suitable for your needs. Once you are happy with your choice, then—and only then—is the time to buy.

CANON EOS 7D
My current camera is the Canon EOS 7D, chosen after extensive research. Key to this was reading reviews that I trusted, before I decided that its specifications were suitable for my needs.

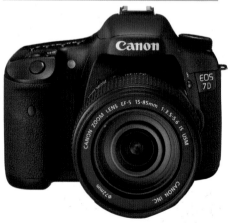

STEPS *(Opposite)*
My requirements in a camera are specific to my personal way of working. For me, a relatively lightweight, but weather-sealed camera, is important.

Canon EOS 7D with 50mm lens, 4 sec. at f/16, ISO 100

Photographic equipment

It should go without saying that photographic equipment is the most important part of shooting RAW, but what equipment you choose will also have a bearing on how easy or frustrating your life as a RAW photographer will be.

Cameras

The most obvious piece of equipment that you will need to shoot RAW files is a camera, but not all cameras have a RAW option. Most compact digital cameras only shoot JPEG files, for example, and while there are a few notable exceptions, these tend to be the most expensive in a manufacturer's compact digital camera line-up.

The camera type most associated with the ability to shoot RAW is the interchangeable lens camera. The most common of this type is the digital single lens reflex camera (or DSLR).

The first digital interchangeable lens cameras were all DSLRs, which were essentially based on their film predecessors. Manufacturers such as Canon and Nikon still adhere to that basic paradigm, but there is now a proliferation of interchangeable lens cameras that have eschewed the mirror for a pure "Live View" approach to viewing and composing images. The most successful of this type are the Olympus and Panasonic Micro Four Thirds ranges, which were first announced in 2008. These cameras now have competition in the form of the Sony NEX series of cameras, launched in 2010.

Regardless of its type, an interchangeable lens camera is just one part

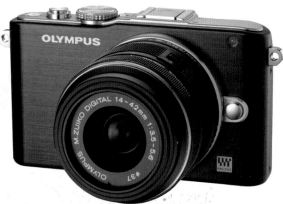

MICRO FOUR THIRDS
Olympus's E-PL3 is an interchangeable lens camera that is almost as small as a compact digital camera, but with the capabilities of a digital SLR.

of a larger "system." Which brand (or system) you choose will determine the range of lenses and other equipment you can buy, such as battery grips, flashes, or remote releases. If you are thinking about upgrading from a compact digital camera, it is worth considering not just the specifications of your interchangeable lens camera of choice, but also whether its capabilities can keep pace with your needs as a photographer.

Memory cards

As mentioned previously, RAW files take up far more space on a memory card than an equivalent JPEG file. There are two approaches to this problem. The first is to have a single high-capacity memory card that is used throughout a photography session and then emptied when convenient. The other approach is to use a number of smaller-capacity cards and swap them out frequently as they are filled.

In many respects the latter approach is the safer of the two, as the loss of one card with a small selection of images is less disastrous than losing a card that contains all of your images, regardless of whether this is a physical loss, or a corruption of the data stored on the card.

Using numerous cards does require a disciplined approach to your photography, though. What you don't want to do is accidentally format a card before you have had a chance to empty it. If your camera uses SD memory cards, it is worth setting the write-protect tab to "lock" until the content has been copied to your computer. This is not something you can do with compact flash memory cards, so I use a simple rubber band fitted around my memory cards to instantly tell me that they've been used. This is only taken off when I come to copy the card to my computer.

Due to their size, RAW files will take slightly longer to write to a memory card than a JPEG, so in addition to capacity, you need to consider a card's read/write speed as well. A simple rule is to buy the fastest memory card you can afford, although this may entail a compromise with capacity. Memory card speed will be particularly important if you also plan to shoot video with your camera.

SD MEMORY CARDS
For most photography sessions a 4GB (Gigabyte) or 8GB memory card is usually more than sufficient.

Lenses

Many cameras come with a kit lens, typically a wide-angle to short telephoto zoom. These lenses are generally not the best of their kind, but they are a good starting point when you begin your photographic journey.

One of the problems with a kit lens is its relatively small maximum aperture—it is difficult to produce a zoom with a large maximum aperture economically. Small maximum apertures result in darker viewfinders and less efficient autofocus, and—in terms of technique—it is more difficult to achieve selective focus effects. However, zoom lenses with large maximum apertures tend to be very expensive and also very heavy as more glass is used in their construction. As with most aspects of photography there are always compromises to be made when buying lenses.

One category of lens that a lot of photographers discount is primes, which are lenses that have a fixed focal length. The main drawback is that they are less flexible than zoom lenses: if you want to change the size of your subject in the frame you have to physically move backward or forward. This also means that to cover the same focal length range as a single zoom lens, you would need a number of prime lenses, increasing the weight of your camera bag, as well as the expense involved.

Don't discount prime lenses, however. I use a 50mm fixed focal length lens a lot in my photography. It is a very fast lens (the maximum aperture is f/1.4) and the perspective of images shot with the lens looks natural. Most importantly, the optical quality is excellent—markedly better than one of my zooms set to the same focal length.

50MM LENS
My 50mm fixed focal length lens is a great "walk-around" lens, thanks to its light weight and fast maximum aperture.

Canon EOS 7D with 50mm lens, 1/320 sec. at f/2.5, ISO 100

Camera: Canon EOS 7D
Lens: 50mm lens
Exposure: 1/100 sec. at f/2.5
ISO: 800

PRIME LENSES

If a camera comes with a kit lens, it is usually a zoom. For most photographers the advantages of a zoom—the ability to precisely frame by changing the focal length—outweigh the disadvantage of a (usually) relatively small maximum aperture. Prime lenses—lenses with a fixed focal length—generally have wider maximum apertures. In certain conditions, a prime lens set close to maximum aperture will allow you to handhold your camera successfully without resorting to an unnecessarily high ISO setting.

Lens problems

There is no such thing as a perfect lens, and all lenses suffer from one fault or another. When shooting film, there was very little that could be done to correct these problems, but shooting RAW, and using software such as Adobe Lightroom, allows us to reduce—or even eliminate—some of these faults.

Distortion

The effects of lens distortion are seen most readily when there are lines that should be straight in an image. The horizon when looking out to sea is a good example: if the horizon is curved in an image, this is due to lens distortion. Distortion can either be "barrel" or "pincushion." The first refers to a distortion that causes straight lines to bow out from the center, toward the edge of the image, while the second refers to distortion that causes straight lines to bow inward, toward the center of the frame.

Typically a zoom lens will display one type of distortion at one end of the zoom range and the second type at the opposite end of the range. You are also more likely to see distortion in an image shot with a wide-angle lens than a telephoto. Fortunately, unless you are regularly shooting straight lines, distortion—unless extreme—is often not noticeable. If it is, then you can correct for distortion in Adobe Camera Raw and Lightroom, as well as most other image-editing programs.

PINCUSHION DISTORTION
This is an example of "pincushion" distortion. The straight red line shows where the horizon should ideally be.

Chromatic aberration

Visible light is a spectrum of wavelengths of electromagnetic radiation that our eyes can see and interpret. The longest wavelength in this spectrum corresponds to the color we see as red, the shortest to blue/violet. A lens that suffers from chromatic aberration (often shortened to CA) is not able to focus these different wavelengths of light at the same point (on the sensor). This results in colored fringing around the boundaries of light and dark areas of an image, especially toward the edges of the frame. Chromatic aberration is usually either green-red or yellow-blue.

There are two types of chromatic aberration: axial and transverse. Axial CA is seen across the whole of the image when the lens is set to its maximum aperture, but is reduced as the lens is stopped down. Transverse CA is seen in the corners of images and is visible at all apertures.

Of the two types, transverse chromatic aberration is easiest to correct for, and both Adobe Camera Raw and Lightroom have functions to reduce it. Unfortunately, axial CA is more difficult to correct, so without a lot of Photoshop work, the only way to avoid its effects is to avoid using aperture settings close to maximum.

AXIAL CA
My 50mm lens's maximum aperture setting of f/1.4 has resulted in axial chromatic aberration, which is visible in the high-contrast boundaries between white and black.

Canon EOS 7D with 50mm lens,
1/50 sec. at f/1.4, ISO 400

Vignetting

An image suffering from vignetting has edges that are noticeably darker than the center of the frame. Vignetting occurs most often when a lens has been set to its maximum aperture: stop the aperture down from maximum and the problem is usually resolved. Wide-angle lenses are generally more prone to vignetting than telephoto lenses are.

Lens profiles

The good news about lens "problems" is that the foibles and flaws of a lens type can be measured. You do occasionally get "rogue" lenses with individual faults, but generally all lenses of a particular design will have the same flaws, and the measurements of these can be used to build a "lens profile." The profile can then be used to determine specific corrections to an image that can be applied to reduce or eliminate the flaws of the lens.

Some cameras have a range of lens profiles built-in and can apply these corrections when

creating JPEGs, but RAW files cannot have any lens corrections applied in-camera—that would go against the idea of RAW. However, compatible software can be used to make corrections when the RAW file is processed. The type of lens used is read from the image metadata and if that lens profile is available, the corrections can be applied quickly.

If you use the RAW software that came with your camera—and it supports lens profiles—then you will probably find that profiles are only available for lenses produced by your camera manufacturer. Adobe Lightroom 3 and Adobe Camera Raw 6 are more generous, and include lens profiles for a wide range of lenses.

Why not try?

Downloading the Adobe Lens Profile Creator will allow you to build your own lens profiles for your Adobe software. http://labs.adobe.com/technologies/lensprofile_creator/

VIGNETTING
My lens was at its maximum aperture to capture this image. This has resulted in noticeable vignetting, but in this instance I quite like the effect—not every lens flaw needs to be corrected.

Canon EOS 7D with 50mm lens, 1/100 sec. at f/1.4, ISO 400

Camera: Canon EOS 1Ds
Lens: 50mm lens
Exposure: 9 sec. at f/13
ISO: 100

RAW EDITING

Successful night photograph is more easily achieved by shooting at dusk—approximately half an hour after sunset—when there is still color in the sky. If you have several shots planned, start shooting facing east, as this part of the sky will darken first, and finish facing west.

Computer hardware

RAW files cannot be processed in your camera; they first have to be copied to a computer. Embarking on the RAW journey therefore involves decisions about what computer hardware you wish to use.

Desktop or laptop?

After your camera and lenses, the next important item on your list is a personal computer. This can either take the form of a desktop tower with a separate monitor, an all-in-one unit such as Apple's iMac series, or a laptop. Which you choose will depend on your needs—if you travel a lot, a laptop would make sense, for example. However, there are invariably compromises to size that can make laptops less than ideal for RAW conversion work, and it is unusual to find a laptop that is the equal of a desktop PC for the same price. Adding more memory or a larger hard drive is often more expensive than adding the same or similar to a desktop computer, but who wants to carry a desktop computer onto a plane as hand luggage?

The higher the resolution of your camera, the better the performance of your PC will need to be. More resolution means more data to process and a slow PC that grinds its way through editing tasks will quickly become frustrating. Adding more memory (RAM) can often improve matters greatly, especially as when an application such as Photoshop runs out of physical memory it will start to use the hard drive as "virtual" memory instead. As a hard drive is a mechanical device, it takes longer to read and write data, causing delays to the completion of tasks.

A full hard drive will compound the problem of a PC running out of steam, so for that reason it's worth investing in the largest hard drive you can, or consider adding a second if there is space. The higher the resolution of your camera the larger the resulting RAW files will be, and it doesn't take long to amass tens of gigabytes of RAW files—and this is before you've converted them to JPEGs or TIFFs that also need space on the hard drive.

PORTABILITY
Laptops such as those in Dell's Inspiron series are a good choice if you are a frequent traveler. Courtesy of Dell Inc. www.dell.com

Windows versus Mac

If you're contemplating buying your first PC, then perhaps your first choice is whether to buy one that runs Windows, or an Apple Mac. Both systems have their adherents who will forcefully defend it against the other, but it's probably fair to say that both systems have their strengths and weaknesses.

Most of the essential software you'll need is available for both Windows and Mac operating systems: Adobe supplies Photoshop and Lightroom for both, and other productivity software, such as Microsoft Word, is also readily available to run in either environment.

Where a Mac loses to a Windows PC is in the amount of useful photographic freeware and shareware that is available—free and low-cost programs and utilities. However, this is changing slowly and there is now a wealth of indispensable software available from the Apple Apps store. Macs are also generally more expensive than an equivalent Windows computer, and it is more costly to expand their initial capabilities with additions such as a second hard drive. Mac supporters would argue that the cost difference is easily narrowed by the fact that Macs are more of an "all-in-one" solution than a Windows PC, and don't necessarily require the purchase of extras such as anti-virus software.

Unfortunately there isn't the space in this book to list all of the arguments that could be made for both systems, so whether one or the other is right for your needs is very much a personal decision. If possible, try both systems before you buy and canvas the opinion of friends who may have experience of one or the other. Whichever you choose, learn how to use it well to get the most of what it has to offer.

Note

The term PC has become shorthand to describe a Windows computer, but as PC is an acronym of "personal computer" it applies equally to Apple Macs. In this book, PC refers to a personal computer, and not just to one running the Windows operating system. The two systems, when referred to specifically, will be described as either Windows or Mac.

ALL IN ONE
The Apple iMac series is a neat combination of monitor and computer system.
© Apple Inc. www.apple.com

Displaying RAW files

Support for RAW files is built into the operating system on the Apple Mac (since OS 10.4), so applications such as Aperture are able to use this facility to render and display RAW files. Regular updates to the OS ensure that newer RAW formats are catered for.

Both Windows Vista and Windows 7 support the WIC codec standard, which means that if a manufacturer supports this standard and produces a suitable codec for their RAW files, Vista will be able to display the files in applications such as Windows Photo Gallery. So far companies such as Canon, Nikon, and Sony have all produced WIC codecs.

Tablet devices

Until recently, a laptop was the only option available to the photographer who was away from home, but needed to view and convert RAW files "in the field." Now, tablet devices such as the Apple iPad, are a viable alternative. There are still some issues that make these devices less than ideal for serious work—a lack of storage space, relatively slow processors, and low-resolution screens that (generally) can't be color calibrated—but their small size makes

them ideal if you need something discreet that can be carried in your camera bag.

The iPad has quickly established itself as the market leader, although tablet devices that use Google's Android OS are increasingly popular. The applications (or apps) that are available for tablet devices generally aren't as sophisticated as software such as Photoshop, so serious image-editing should still wait until you have access to a standard PC. However, as most table devices have built-in Wi-Fi connectivity, it is perfectly possible to quickly convert RAW files to JPEG and then email them onward or upload them to an online file-storage service.

Why not try?

Filterstorm Pro for the iPad 2 has a variety of image-editing tools and supports compatible RAW files up to 22 megapixels. It also allows FTP file transfers.

APPLE iPAD
The market-leading tablet device.
© Apple Inc. www.apple.com

Monitors

There is a number of factors that you need to consider when buying a monitor. The first, and perhaps most important factor is size. Most monitors now have an aspect ratio of 16:9, which is the proportion of the width of a monitor compared to its height. So, if the width were 16 inches, the height would be 9 inches. However, the size you will see quoted when you are buying a monitor is the diagonal distance from the top left corner to the bottom right. As I write this, I'm looking at a 27-inch screen, which is 23 inches wide by 13 inches high.

The bigger the screen, the greater the resolution is likely to be, and resolution is important, particularly if you want to use your monitor to display the output from an HD source such as a Blu-ray player (your monitor

should be HDCP compliant if this is something you plan to do). True HD requires a resolution of at least 1920 x 1080 pixels. The inputs available on the back of a monitor will also determine how useful it is as an HD device. The monitor should have HDMI or DVI ports as well as a VGA connection for maximum flexibility.

Another important factor, which is a little less obvious is the monitor's viewing angle. Cheaper LCD screens often have a relatively small viewing angle, and if you stray away from the optimum viewing angle the screen will appear to darken and the colors will shift their hue. This is not ideal if you want to produce consistent and accurate color images, so a viewing angle of more than 160 degrees should be the minimum you consider in a monitor.

Finally, once you've bought your monitor you should calibrate it for color accuracy and leave it to warm up for at least ten minutes before attempting critical image editing.

IIYAMA PROLITE E2473HDS
An HD-ready 24-inch monitor.
www.iiyama.com

Color calibration

The color output of your monitor is unique: no other monitor will be exactly the same. This is potentially a problem if you want accurate color when you view your images on screen and later, when you come to print those images. Color calibrators allow you to measure the color output of your monitor and adjust it to make it more accurate.

Color calibrators are a combination of a colorimeter, which sits over your monitor, and dedicated calibration software. The software displays a series of color patches and the colorimeter measures the saturation and brightness of these. Once the calibration process is complete a file called an ICC monitor profile is created. Your computer's operating system and compatible software (such as Photoshop) will use this profile to modify the monitor output to ensure accurate colors. The color output of the monitor will change over time so it is important to re-calibrate your monitor regularly, ideally at least once a month.

Hardware color calibrators are relatively inexpensive, but if you don't want the expense there are free and shareware software calibrators available. As these rely on user judgement, they are inevitably less accurate, but it is better to make some attempt at calibration rather than none at all. On a Mac, try using the Display Calibration Assistant built into the operating system, or SuperCal, which is available as shareware. For Windows, try QuickGamma.

CALIBRATION
The X-Rite ColorMunki calibrator in use.
http://xritephoto.com

Commercial software

The software you choose to use will have some bearing on how your images will finally turn out. Although all RAW conversion software has basic features in common, some RAW software is better specified than others.

Proprietary RAW converters

If your camera can record RAW files, then it will undoubtedly come with software created by the manufacturer to process those files (with the exception of the Leica M9 family, whose owners can download Adobe Lightroom). Although this is convenient, the disadvantage is that the quality of the software isn't always as good as the commercial alternatives, and it may be less

well specified. If you intend to convert your RAW files to DNG, you'll find that the Adobe format is not likely to be supported by the camera manufacturer's RAW software. That does not mean that the RAW software that came with your camera should be discounted: it is free (or the price is absorbed into the cost of the camera) and it should allow you to make most of the adjustments you'll need to apply to your images.

Manufacturer	RAW Software
Canon	Digital Photo Professional
Fuji	RAW File Converter EX
Hasselblad	Phocus
Kodak	EasyShare
Nikon	ViewNX 2
	Capture NX 2 (usually 60-day trial version)
Olympus	Viewer 2
Panasonic	SILKYPIX® Developer Studio 3.1 SE
Pentax	Digital Camera Utility
Ricoh	Irodio Photo & Video Studio
Samsung	Raw Converter
Sigma	Photo Pro
Sony	Image Data Converter

Adobe Photoshop

Ask anyone to name an image-editing software package and they'll probably say Photoshop. Now in its 12th iteration (confusingly called CS5), Photoshop is an image-editing "Swiss Army knife," with features aimed at a multitude of users from photographers to designers and web site developers.

One of the big strengths of Photoshop is the concept of plug-ins. These are tiny pieces of software that can be downloaded and "bolted" onto Photoshop itself, expanding the range of features available. Adobe Camera Raw is just such a plug-in, and one that allows you to load RAW files into Photoshop. Because Adobe Camera Raw is not built into Photoshop directly, it means that Adobe can update it frequently to keep pace with new camera models. It is then just a matter of downloading the latest Camera Raw plug-in, rather than a new version of Photoshop. Adobe Camera Raw is covered in more depth in Chapter 5.

Adobe Lightroom

Adobe Lightroom shares a lot of Photoshop's core technology and methodology, so it is fairly easy to swap between the two without a crashing of mental gears.

Lightroom is intended as a "one-stop shop," with workflow tools that help you with every image-editing task conceivable, from importing and adding keywords, to printing, without recourse to any other software. However, some photographers—myself included—use Lightroom as the first stage in their RAW file editing and then export the image for a final polish in Photoshop.

> ### Note
> *Adobe Photoshop Elements is a cut-down version of Photoshop and is far less expensive. The latest versions are compatible with Adobe Camera Raw and are a viable alternative to Photoshop.*

PHOTOSHOP
Version CS5.

Apple Aperture

Only available for Mac, Aperture by Apple is an integrated package that allows you to import, keyword, and edit your RAW images. A lot of the tools will be familiar to users of Lightroom, and, in a similar way to Lightroom, the program allows you to make non-destructive edits to your images. However, Aperture has a few tricks up its sleeve when it comes to organizing your photos. These tricks include facial recognition and the use of any embedded GPS metadata to match your photos to a particular location. Aperture also has options for sharing your images on social media web sites such as Facebook and Flickr, as well as for collating them into books for printing by Apple.

DxO Optics Pro

As the name suggests, DxO Optics Pro is far from a simple RAW converter. At its heart is a technology designed to help you correct any optical flaws in your images due to the limits of your lenses. This includes a facility to correct for distortion, chromatic aberration, and image softness. More impressively, extreme lens defects such as volume anamorphosis can be corrected simply and quickly (volume anamorphosis is the apparent stretching of your subject around the edges of an image, typically seen with very wide-angle lenses). This level of control is achieved through profiles that can be downloaded for different lenses, with the corrections specifically targeted for those lenses.

APERTURE
Aperture's Adjustments panel.

DxO OPTICS PRO
Correcting the flaws in a lens.

Corel PaintShop Pro

The original version of PaintShop Pro was released in 1990, predating mainstream acceptance of digital photography by over a decade. It started life as a simple way to convert between image formats such as .BMP and .GIF. Now it is a fully-featured image editor able to import a wide variety of RAW format files. As with Photoshop, PaintShop Pro accepts plug-ins to extend the capabilities of the software. At present PaintShop Pro is only available for the Windows platform. PaintShop Pro is available for download from Corel (www.corel.com). Newer RAW format files may require an update of PaintShop Pro before they can be imported.

Phase One Capture One 6

Produced by Phase One, Capture One 6 is available in two versions: Pro and Express. Capture One 6 Pro is the more expensive of the two, but is more fully-featured than its sibling Express. However, you may find options such as tethered shooting (when the output of your camera is sent straight to your PC over a connecting cable) are not needed. In which case, Express is a good compromise and is competitive in price to Adobe Lightroom. Both versions of Capture One are available for Windows and Mac OS.

As with Lightroom, Capture One 6 is a workflow package in which images can be imported, keywords added and image adjustments made. Images can then be output in the format of your choice for general use.

CAPTURE ONE 6
Adjusting an image. www.phaseone.com

Open-source software

An alternative to commercial RAW conversion software is open-source software. This is software that has often been developed by enthusiasts and is either free or available for a very small fee.

Free software sounds ideal, but there are always potential catches. Because open-source software is not written by a professional team, support is sometimes patchy, and updates may be less frequent than commercial software. Open-source software may also lack polish and be less well-documented. The upside is, of course, the cost, and open-source software often has a devoted following, with online forums where help is readily found.

GIMP

GIMP, or the "GNU Image Manipulation Program" to give it its full title, is the most popular open-source photo editor. It is available for Windows, Mac, and Unix systems and if you are familiar with Photoshop it

will not take you long to understand GIMP's interface. Importing RAW files is achieved either through GIMP or by using plug-ins such as UFRAW (Unidentified Flying RAW). Although using GIMP is relatively straightforward, some technical knowledge is needed to install both it and any plug-ins you may wish to use.

Darktable

Darktable is a RAW editing and workflow tool for Unix-based computer systems (including Mac OS X). As with Lightroom, editing RAW files is non-destructive, with edits only applied to the exported file when it is converted to another format such as JPEG. A working knowledge of the UNIX operating system is highly recommended, though.

GIMP 2.6
GIMP running under the Mac OS X operating system.

An often-overlooked piece of equipment that will improve your photography is the humble tripod. They are crucial when shutter speeds are too long to handhold your camera successfully. Using a tripod will help to unlock your creativity, as it will expand the exposure options open to you.

Camera: Canon EOS
1Ds MkII
Lens: 17–40mm lens
(at 20mm)
Exposure: 15 sec. at f/16
ISO: 100

Compact digital cameras

There are relatively few compact digital cameras that can shoot RAW files, but Canon's Powershot G series of cameras is in this select group. To get the best out of these cameras, good technique is arguably more important than when shooting with an interchangeable lens camera. This means "exposing to the right" and using a low ISO setting to keep noise to a minimum.

Camera: **Canon Powershot G10**
Lens: **6.1–30.5mm lens (at 8.9mm)**
Exposure: **1/1000 sec. at f/4**
ISO: **80**

CHAPTER 3 CAPTURING RAW

Introduction

RAW is a far more forgiving file format than JPEG when it comes to post-production. For that reason it is all too easy to think that bad or indifferent photography can be rescued at the conversion stage.

Good camera technique has never been more important, just as cameras have never been so complicated! Although there is not the space in this book to cover every mode and option on every camera, this chapter acts as a short guide to some of the basic concepts that are common to all cameras.

Understanding how your camera works is largely a matter of practice, although it may seem daunting at first. One way to break yourself in gently is to concentrate on one aspect of your camera at a time and to not move on until you have understood it thoroughly. Keeping your camera manual with you in your jacket pocket or bag is a good idea, but if your camera did not come with a manual (some manuals are supplied on CD) you could print off the most relevant and useful pages. Some manuals also include "quick guides" that cover the essentials in a few pages.

One of the big advantages of digital photography is that each image is essentially "free," which makes experimentation a far more appealing prospect—there is no cost penalty for making mistakes. In fact, making mistakes is often the best way to learn.

Reading the image EXIF metadata after you have taken your shots is also recommended, as knowing how you created one image will allow you to apply that knowledge the next time that you are in a similar situation.

FILM
This is one of my very first photographs, shot on print film. I have no idea what exposure settings I used, although I can make an educated guess. Shooting digitally wasn't an option then, which is a pity as I am sure I would have learned about photography more quickly.

SHADOWS (Opposite)
I knew from looking at this scene that the shadow areas would be deep and lacking in detail when I made the image. To compensate for this I used a reflector to bounce light back into the shadows.

Canon EOS 7D with 50mm lens, 1/200 sec. at f/2, ISO 400

Exposure

At a basic level, photography is about using light to create a permanent image. The art of photography is learning to appreciate and control the quality and amount of light needed to make a pleasing image.

Controlling light

The amount of light that reaches the digital sensor in your camera is controlled in two ways. The first is by varying the amount of time that the sensor is exposed to light. This is achieved through the use of a shutter in the camera that can be opened and closed. The second method is to adjust the size of an aperture that is mounted within the lens, enabling more or less light to pass through.

The length of time that the shutter is open is known as the shutter speed, and on most modern cameras this can be anywhere from 1/8000 sec. to 30 seconds. Some cameras also have a Bulb mode that locks the shutter open when the shutter-release button is held down and only closes it when the shutter-release button is released.

Shutter speeds are varied on a camera by set amounts, such as 1/500 sec., 1/250 sec.,

> ### Note
> *Some cameras allow you to vary the shutter speed and aperture in ½- or ⅓-stop increments. For example, 1/160 sec. and 1/200 sec. are ⅓-stop increments between 1/125 sec. and 1/250 sec., while f/9 and f/10 come between f/8 and f/11.*

LOW LIGHT
When light levels are low it's often necessary to use a long shutter speed to gather enough light to make a good exposure. This image required a shutter speed of 3.2 seconds.

Canon EOS 7D with 17–40mm lens (at 40mm), 3.2 sec. at f/16, ISO 100

1/125 sec., 1/60 sec., and so on. The difference between these values is referred to as "one stop," where each stop represents either a halving (as the shutter speed gets faster) or a doubling (as it gets slower) of the amount of light that reaches the sensor. For example, a shutter speed of 1/125 sec. lets twice as much light through as a shutter speed of 1/250 sec., but half that of a 1/60 sec. shutter speed.

Within a camera lens is a variable iris known as the aperture. The aperture can be adjusted in size to control the amount of light that passes through. The size of the aperture is measured in f-stops, represented by f/ and a suffix number. These are actually fractions, and a typical range of whole

f-stops on a lens is f/2.8, f/4, f/5.6, f/8, f/11, and f/16, where higher numbers after the f/ denote a smaller aperture (hole).

As with shutter speeds, altering the aperture value by a full stop will either halve or double the amount of light that is allowed to pass through. So, f/8 will allow in half as much light as f/5.6, but twice that of f/11. The design of a lens will determine the maximum (or largest) and minimum (smallest) apertures that are available.

Shutter speed and aperture

The shutter speed and aperture have a reciprocal relationship. If you've determined the correct exposure for a scene but wish to alter the shutter speed, the aperture must also be changed to maintain the same exposure. When the shutter speed is made faster by one stop, the aperture must be opened by a stop to compensate. If the suggested exposure is 1/125 sec. at f/11, for example, and you change the shutter speed to 1/500 sec., the aperture must be altered to f/5.6 to maintain the same exposure overall. Different combinations of shutter speed and aperture will alter the look of your images, so knowing which combination to use is one of the creative joys of photography.

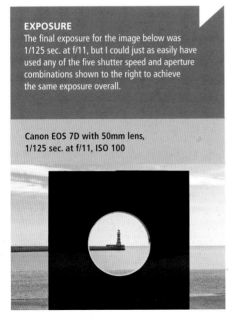

EXPOSURE
The final exposure for the image below was 1/125 sec. at f/11, but I could just as easily have used any of the five shutter speed and aperture combinations shown to the right to achieve the same exposure overall.

Canon EOS 7D with 50mm lens, 1/125 sec. at f/11, ISO 100

Shutter Speed/Aperture

Shutter Speed:

1/500	1/250	1/125	1/60	1/30

Aperture (f-stops):

f/5.6	f/8	f/11	f/16	f/22

Depth of field

When a lens is focused, an ultra-thin plane of sharpness is created parallel to the camera at the point of focus. Everything on either side of the point of focus is soft, or out of focus to a certain degree. This raises the question of how photographers achieve sharp pictures from the front to the back of a scene. Fortunately, the lens's optical system isn't the only element that is used to create sharp pictures—the aperture inside the lens also has a focusing effect.

As the aperture is made smaller, this focusing effect increases, extending the zone of acceptable sharpness both forward and backward from the focus point. The extent of this zone of sharpness is known as the depth of field. Depth of field always extends further back from the focus point than it does forward.

The extent of the depth of field that is achievable is governed by two other factors. The first is the focal length of the lens, with shorter focal length lenses having greater inherent depth of field at any given aperture than longer focal length lenses. The longer the focal length of a lens, the more difficult it is to achieve front-to-back sharpness in an image, even when using the minimum aperture setting.

The final factor is the distance from the lens to the focus point. The closer the focus point is to the lens, the less depth of field there is. For this reason, achieving acceptable sharpness beyond the focus point is often difficult when shooting macro photos.

Depth of field can be used creatively: landscape photographers often use a "deep" depth of field so that everything in the image, from the foreground to the distant horizon, is pin sharp, while portrait photographers often use a shallow depth of field so that only a small sliver of their subject is in focus.

FRONT-TO-BACK SHARPNESS *(Top Left)*
I wanted everything in this image to be sharp. Depth of field extends further back from the focus point than it does forward. Knowing this, I focused on the lobster pot in the foreground. I then set the aperture so that the depth of field covered the wall at the front of the scene to the houses behind.

Canon EOS 7D with 17–40mm lens (at 21mm), 1/20 sec. at f/14, ISO 100

MINIMAL SHARPNESS *(Top Right)*
Not everything in your images needs to be sharp. Here I focused on the subject's eyes and used a large aperture to make sure that little else—apart from the eyes—is sharp.

Canon EOS 7D with 50mm lens, 1/60 sec. at f/2, ISO 1250

SHUTTER SPEED *(Bottom)*
Using a small aperture often means using a longer shutter speed. A breeze was blowing when I shot this image, so I had to be careful that the moving leaves in the foreground didn't obscure the Abbey on the left during the exposure I needed.

Canon EOS 7D with 17–40mm lens (at 22mm), 1.6 sec. at f/18, ISO 100

Shutter speed

When you press down on the camera's shutter-release button, the sensor is exposed to light for a set period of time. If your subject doesn't move during this time you could use any shutter speed you desired (within the limits of the available apertures) and it would make little difference to the image (although the depth of field would be altered if you adjusted the aperture as well).

However, if your subject is moving, the shutter speed will have a big impact on how the subject is captured in the final image. Most modern cameras can use shutter speeds up to 1/4000 sec. or 1/8000 sec. This is astonishingly fast, and is generally quick enough to "freeze" all but the very quickest movement. If you were shooting racing cars or fast jets you would need to be using similar shutter speeds.

Not everything moves so quickly though, and slower movement doesn't require such short shutter speeds if the purpose is to capture sharp action. A shutter speed of 1/500 sec. is generally fine if you want to "freeze" a person running, and 1/125 sec. is sufficient for a person walking (these are approximations—the closer the person or subject is to the camera, the faster the shutter speed will need to be).

When the shutter speed is slower—perhaps lasting whole seconds, minutes, or even hours—a moving subject will be blurred. Esthetically this can be very pleasing: blur helps to create a sense of movement, often conveying this more successfully than a pin-sharp image. However, note that the longer the shutter speed, the more likely it is that your subject will vanish from the picture entirely, or at least be unidentifiable.

When the light levels are high, it can be difficult to achieve slow shutter speeds, even when the ISO and aperture are at their minimum settings. To artificially "lower" the light levels, photographers use ND (neutral density) filters that reduce the amount of light entering the lens so that longer shutter speeds (or larger apertures) need to be used.

FLOWER POWER (*Opposite*)
This shot proved to be a challenge, as a stiff breeze was blowing these flowers around. I could either shoot with a wide aperture to maximize my shutter speed (top), or use a smaller aperture and a slower shutter speed, knowing that the flowers would move during the exposure (bottom). Personally, I like the more abstract feel of the second image, as it helps to convey the sense of movement in the flowers. However, this is entirely subjective and is by no means the "correct" answer.

Canon EOS 7D with 70–200mm lens (at 200mm),
1/100 sec. at f/4, ISO 100 (top)
10 sec. at f/25, ISO 100 (bottom)

Metering

The accurate measurement and assessment of the light falling onto the scene you want to photograph is the key to achieving consistently usable RAW files.

Measuring light

There are two common types of lightmeter; incident and reflective. Incident lightmeters measure the amount of light falling onto a scene. They are typically small, handheld devices with either an analog or digital readout. The lightmeter in your camera is the reflective type, which means that it measures the amount of light that is reflected back to the meter from the scene itself.

Although reflective metering is usually accurate, it can be fooled by the reflective qualities of the scene being metered. Reflective meters don't "see" in color, only in shades of gray, and they assume that the scene being metered reflects about 18% of the light that falls onto it—the same amount of light that a matte mid-gray surface would reflect. A photographer's 18% graycard does just that and is often used to achieve accurate exposures. In the real world, grass and stone are two surfaces that roughly equate to this ideal reflectivity. A cloudless blue sky, approximately 90 degrees to the sun, also approximates to mid-gray.

This is fine if your scene is nice and average in its tonal content, but an above-average amount of dark or light tones in a scene can fool a reflective meter into over- or

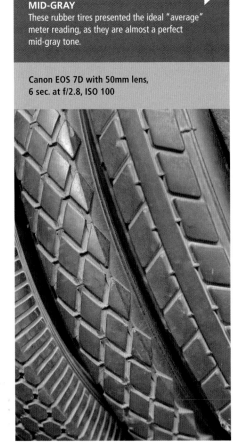

MID-GRAY
These rubber tires presented the ideal "average" meter reading, as they are almost a perfect mid-gray tone.

**Canon EOS 7D with 50mm lens,
6 sec. at f/2.8, ISO 100**

underexposing respectively. In a predominantly dark-toned scene—a black cat in a coalmine, for example—the camera meter would tend to overexpose. It is doing this to push the dark tones closer to the mid-gray ideal.

To overcome the limitations of a reflective meter it is important to assess the scene that you wish to photograph, looking at it in terms of both tone and reflectivity. This is more easily achieved if your camera has Live View and a histogram, but with practice it becomes easier to "eyeball" a scene and decide whether or not exposure compensation is necessary.

Dynamic range

Unfortunately, cameras do not yet have the ability to record the range of luminance levels that we can distinguish with our eyes. The range of luminance (or brightness) levels a camera is able to record successfully is known as its dynamic range. This varies from model to model, but compact digital cameras typically

have a smaller dynamic range than cameras with larger sensors.

Some scenes are relatively easy for a camera to cope with: misty landscapes typically have a very narrow luminance level range with few, if any, bright highlights or deep shadows, for example. More difficult is a reflective subject lit by a direct light source. On the lit side of the subject there will be bright highlights and on the unlit side there will be deep shadows (this is assuming there is no reflected light softening the shadow areas). In this situation you will be able to set the camera's exposure to record either the highlights or shadows correctly, but not both at the same time—the dynamic range of the camera is too small.

A number of methods can be used to overcome the limitations of a camera's dynamic range, such as using graduated neutral density filters or by shooting several different exposures of a scene and blending the resulting images using HDR software.

LOST DETAIL
The areas of bright red in this photo show where I have lost detail in the highlights. This was a scene with a wide range of different luminance levels. If I had exposed for the highlights, the foreground would have been unacceptably dark.

Canon EOS 7D with 17–40mm lens (at 17mm), 8 sec. at f/4, ISO 100

The histogram

It is easy to rely on the post-capture image on the LCD of your digital camera to check whether the exposure is correct, but this approach is flawed. Fortunately, digital cameras offer a better method of assessing an image accurately.

A graphical representation

Ambient lighting conditions may fool you into thinking that the captured image on your camera's LCD is brighter or darker than it actually is—look at the screen at night and the image shown will appear much brighter than it would in direct sunlight. Therefore, learning to read an image's histogram is a more objective way to assess the exposure. A histogram is a graph that shows the distribution of tones in an image. The horizontal axis represents the potential range of tones in an image, with black (shadows) on the left edge, midtones halfway across, and then white (highlights) on the right edge. The vertical axis shows the number of pixels in the image that correspond to a particular tone.

By looking at an image histogram you can quickly determine whether an image is correctly exposed, underexposed, or overexposed. If the histogram is pushed too far to the left or right, so the graph appears to be pushing against the wall of histogram, it is described as being "clipped." This means that there are pixels in your image that are either pure black or pure white. Cameras often show this is happening by "blinking" the affected areas in the image on the LCD. When this happens there is no detail recorded in those pixels, and no matter how much you adjust the brightness of your picture in your image-editing program you can never regain that lost detail (a certain amount of highlight clipping can be recovered in Adobe Camera Raw and Lightroom).

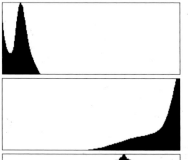

The histogram here is badly skewed to the left, with no tones lighter than mid-gray. The shadow areas are clipped, indicating a loss of detail in the darkest areas of the image.

Virtually all of the tones shown in this histogram are lighter than mid-gray. The highlights have been clipped, indicating loss of detail in the brightest part of the image.

The tonal range is better distributed in this histogram, with no clipping at either end. This is a far better exposure.

Shooting JPEG

When you are shooting JPEGs it is important to achieve the correct exposure for an image, particularly if you don't intend to do any post-processing. When looking at an image's histogram it is vital to remember that there is no ideal shape for a histogram, as a histogram merely shows the range of tones in the image. If there are a lot of dark or light tones in the scene, then the histogram will be skewed to the left or right respectively. This is not incorrect, and is not objectionable, unless the histogram shows clipping and you are losing important detail in the shadows or highlights. If this happens, you would use exposure compensation to alter the exposure as necessary.

With traditional, film-based photography the golden rule when shooting with slide film was not to lose detail in the highlights. If this meant that the shadows areas were dense—and nothing could be done to lighten them at the time of exposure—this was seen as the lesser of two evils. In many respects this is also true of shooting JPEGs in the digital age, and you should try to bias the exposure so that the highlights are not blown out. The reason for this is that it is far easier to recover detail from shadow areas than from blown highlights.

Note

Some cameras can display both a brightness (or luminance) and RGB histogram. A brightness histogram simply shows the tonal distribution of an image (as though it had been converted to shades of gray), while an RGB histogram shows the mix of primary colors in an image and can be used to assess white balance.

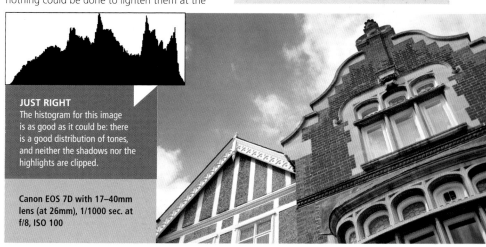

JUST RIGHT
The histogram for this image is as good as it could be: there is a good distribution of tones, and neither the shadows nor the highlights are clipped.

Canon EOS 7D with 17–40mm lens (at 26mm), 1/1000 sec. at f/8, ISO 100

Exposing to the right

Shooting and exposing RAW images is a slightly different process to shooting for JPEG. Less noise and more usable image data is recorded in the lighter tones of an image than the dark tones. Therefore, if you were to deliberately underexpose an image and then correct the exposure in post-production, you would see a noticeable increase of noise across the image. However, starting with a light image and then darkening it does not have the same detrimental effect on image quality.

This process is known as "exposing to the right"—the deliberate exposure of an image so that the histogram is skewed to the right as far as possible, without clipping. Of course, this may make the image on your camera LCD appear washed out, but as this will be fixed in post-production it is not something to worry about. By exposing to the right you will be maximizing the amount of "clean" image data captured by the camera and minimizing the amount of coarse, "noisy" data.

Note

A typical 12-bit RAW file can record 4096 discrete tonal values for each pixel, with white being the brightest value that can be recorded and black being the darkest. The lightest area of an image is allocated 2048 of these tonal values, or half the available range. Halve the brightness and 1024 tonal values are used. Halve the brightness again and this time only 512 tonal values are used. By the time you reach the darkest possible areas of the image only 32 tonal values are available to record these tones.

WASHED OUT
I "exposed to the right" when shooting this image. The results on the camera's LCD were not great, but I knew that this wasn't relevant. The aim was to capture as much "good" information in the darker areas as possible and the histogram showed that I had achieved this.

Canon EOS 7D with 17–40mm lens (at 17mm), 30 sec. at f/8, ISO 100

Preview

Ironically, one of the problems with the technique of exposing to the right is the camera's histogram. The histogram is not generated from the RAW data, but from the embedded JPEG preview. On some cameras this JPEG is generated using the current picture settings so, for example, the camera may be using a "vivid" picture style in which the color saturation and contrast are set to high. This will subsequently have an affect on the image's histogram, which may then not match the histogram you see when you open the RAW file in your editing software.

As a general rule, if the JPEG histogram is fine, the histogram for the RAW file will also be OK, but it is a good idea to use "neutral" JPEG picture settings for the greatest accuracy.

Note

When exposing to the right you may well have to override the metering on your camera. This can be achieved by using exposure compensation or by switching to manual exposure. You will probably need to "overexpose" the settings suggested by the camera meter, which will involve either a longer shutter speed or wider aperture. Keep the ISO at the lowest setting you can, so that noise is kept to a minimum.

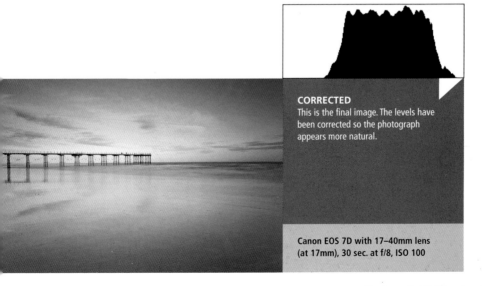

CORRECTED
This is the final image. The levels have been corrected so the photograph appears more natural.

Canon EOS 7D with 17–40mm lens (at 17mm), 30 sec. at f/8, ISO 100

Taking control

Exposing for RAW capture involves using techniques to overcome any problems with the dynamic range that you may encounter. There is a number of techniques that photographers use to achieve this.

If the shadows in your scene are particularly dense, they may need to be lightened. This is often achieved with a secondary light source, such as a flash, but the key is not to overpower the shadows so that they are no longer visible—you still want some contrast in your image.

Another way to lighten shadows is to use one or more reflectors to "bounce" light back into the darkest areas. Commercial reflectors come in a range of different sizes (and at a variety of prices), but there is no reason why you cannot use something as simple as a sheet of white card or fabric—it will achieve the same effect as a commercially-made reflector. Colored reflectors can also be used to add a tint to the shadow areas; portrait photographers often use gold reflectors to add warmth to their subjects, for example.

Notes

The techniques noted above can also be used when recording JPEG files to achieve the "correct" exposure.

HDR (High Dynamic Range) imaging is a technique used to increase the dynamic range by combining a number of different exposures. The main drawback is that it works less well with moving subjects.

SOFT LIGHT
Overcast conditions are perfect for intimate natural subjects.

Canon EOS 1Ds MkII with 100mm macro lens, 1/400 sec. at f/4, ISO 100

These techniques work well with relatively intimate subjects, but subjects such as landscapes add the problem of scale. Often the biggest disparity in exposure is between the foreground and the sky, although this can often be overcome with the use of ND graduate filters.

It is also worth noting that landscape photographers generally dislike clear blue skies, because the sunlight is "harder" and produces denser shadows. Shooting at the extreme ends of the day helps, because sunlight is naturally softer when the sun is closer to the horizon. Clouds, however, help a great deal in contrast control. They are natural reflectors that help to bounce light into shadows and when the sky is overcast, the light is softer still—perfect for portraiture and details in the landscape.

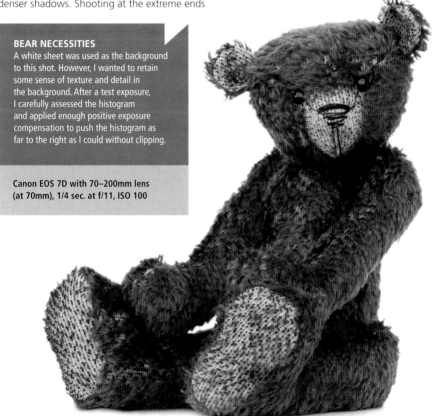

BEAR NECESSITIES
A white sheet was used as the background to this shot. However, I wanted to retain some sense of texture and detail in the background. After a test exposure, I carefully assessed the histogram and applied enough positive exposure compensation to push the histogram as far to the right as I could without clipping.

Canon EOS 7D with 70–200mm lens (at 70mm), 1/4 sec. at f/11, ISO 100

Exposure compensation

It is important to appreciate from the outset that the exposure your camera recommends may not necessarily be the one that you require. This will be particularly true if you are exposing to the right. In manual exposure mode it is straightforward to adjust the exposure as required, but in more automated modes, such as Program, you will need to override the exposure yourself.

This is achieved by using exposure compensation. The amount of exposure compensation you can apply varies between camera models, but is typically ±3 stops (usually in ½- or ⅓-stop increments). Setting positive exposure compensation increases the exposure, resulting in a lighter image, while setting the exposure to a negative value will produce a darker result. If your camera has a Live View facility you should see the results of exposure compensation immediately.

Exposure compensation is also useful if the scene you are photographing is not composed of an "average" range of tones. When shooting snow scenes, for example, it is quite common to have to apply one to two stops of positive compensation to achieve the "correct" exposure for a predominantly bright scene.

Exposure bracketing

If you want to be certain that you have captured the right exposure, then you might want to bracket your exposures. This is a technique where you shoot several shots (most often three) of the same scene, comprising of one at the default exposure, one with positive compensation applied, and one with negative compensation. The theory is that one of the three exposures will be "correct."

Exposure bracketing can be done manually, but most cameras have an automatic bracketing option that will make the exposure changes for you between the three shots. As with exposure compensation, bracketing is usually adjustable by ±3 stops in ½- or ⅓-stop increments. Bracketing is an invaluable tool if you plan to create HDR images in post-production.

SNOW
I had to use +1⅔ stops of exposure compensation for this scene to avoid the snow appearing gray due to underexposure.

Canon EOS 1Ds MkII with 50mm lens, 1/10 sec. at f/18, ISO 100

ISO

There is a third control that allows you to adjust the exposure of your images: ISO. This setting allows you to adjust the sensitivity of your camera's sensor to light.

ISO range

As with aperture and shutter speed, ISO is set in stops (although most cameras allow ½- or ⅓-stop increments). The higher the ISO setting, the less light the sensor needs to make a satisfactory exposure. This means that you can use a faster shutter speed or smaller aperture if necessary. The typical ISO range on a digital camera starts at ISO 100 (often referred to as the base ISO) and ends at ISO 3200. Some cameras have pushed the upper end of ISO sensitivity to ISO 12,800, although this level of sensitivity is not usually necessary in normal lighting conditions.

At this point, you may be thinking that it would be a good idea to leave your camera set to the highest ISO possible. However, this is not the case, as a sensor is optimized to provide the best image quality at its lowest ISO setting. As you increase the ISO, you also increase the presence of noise in your images. If your camera is set to Auto ISO it will change the ISO to suit the lighting conditions to try to maintain a useful aperture and shutter speed combination.

This can be invaluable when you are handholding your camera and are in a situation where the light levels will fluctuate. However, if

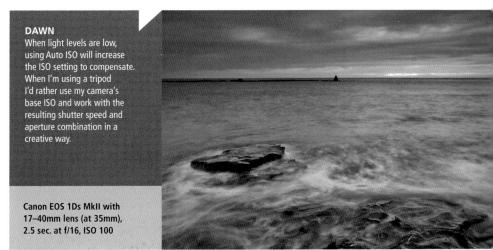

DAWN
When light levels are low, using Auto ISO will increase the ISO setting to compensate. When I'm using a tripod I'd rather use my camera's base ISO and work with the resulting shutter speed and aperture combination in a creative way.

Canon EOS 1Ds MkII with 17–40mm lens (at 35mm), 2.5 sec. at f/16, ISO 100

you are using a tripod it is better to avoid Auto ISO and change the ISO manually instead. This will give you more control over the exposure and allow you to choose the lowest ISO for maximum image quality.

Ultimately, the ISO you choose will depend on whether your desired shutter speed and aperture combination is possible in the lighting conditions you are working in. Although noise is increased as the ISO is increased, this is preferable to unsharp images caused by camera shake.

Noise

Film is composed of an emulsion of silver halide crystals coating a transparent plastic base. When photons of light strike the crystals they react and turn black, forming an image. The larger the silver halide crystals, the more sensitive the film is (in other words, it has a higher ISO rating). However, larger crystals make the film more coarse and grainy. Digital sensors don't use photo-reactive chemicals, but they do become "noisier" as the ISO is increased. Noise

Canon EOS 5D with 200mm lens, 1/160 sec. at f/2.8, ISO 800

TRAVEL
The ability to adjust the camera ISO is invaluable in fast-moving situations where a tripod is impractical and a usable shutter speed is required.

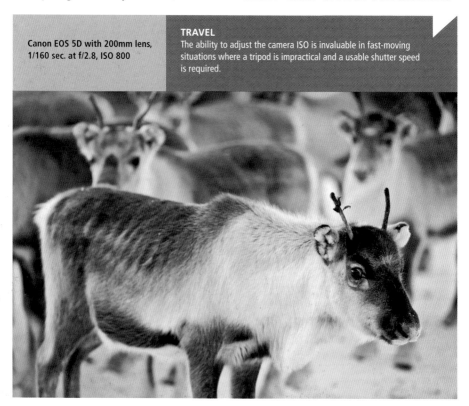

Understanding RAW Photography

is seen as random spots of color, or variations in brightness in an image and the "noisier" an image is, the greater the reduction in fine detail. There are two types of noise; luminance and chroma. Of the two, luminance is the least objectionable as it often resembles film grain, and a small amount can often make a digital image look less "sterile."

Chroma noise is less welcome, though, as it causes unsightly color blotches that reduce the color fidelity of an image. Chroma noise is also more difficult to reduce using software.

Sensor technology is improving all the time, but all sensors suffer from noise to one degree or another. At what ISO setting this is visible or objectionable depends on the sensor, the noise-suppression technology employed by the camera, and the size at which you view your images—the larger the image, the more obvious any noise will become.

Noise is generally more apparent in an image when there are large areas of even tone, such as a blue sky. Underexposing an image and then lightening it at the conversion stage will increase the amount of visible noise, while "exposing to the right" will help you to minimize the noise in your images.

Note

The smaller the sensor in your camera, the more pronounced noise will be, especially at higher ISO settings: compact digital cameras are typically noisier than digital SLRs, for example.

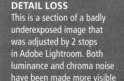

DETAIL LOSS
This is a section of a badly underexposed image that was adjusted by 2 stops in Adobe Lightroom. Both luminance and chroma noise have been made more visible as a result.

Canon EOS 7D with 17–40mm lens (at 32mm), 1/80 sec. at f/11, ISO 100

Noise reduction

If you are shooting JPEGs, there are two ways to combat noise: using your camera's built-in noise reduction system, or in post-processing. With RAW images, reducing image noise is restricted to the latter, and most good RAW conversion software will have a noise reduction option.

How much you want to reduce the noise by in an image is a personal choice and one that will depend a great deal on the type of images you shoot. If you intend to convert your image to black and white, you may actually prefer a slightly grittier look—perhaps even by adding some noise!

Noise reduction is usually applied separately to both the luminance and chroma noise and most RAW software uses a slider to set the amount of noise reduction. As with most aspects of photography there is often

a compromise that needs to be made: apply too much noise reduction and your images will look unnaturally smooth, as though they have a plastic finish. When this happens, the noise reduction has started to affect the fine texture in your image, so you may find that to maintain the integrity of your image you have to accept some visible noise.

Note
Noise can become a problem when you are shooting long exposures (typically longer than one second). Most cameras can combat long-exposure noise in-camera—even with RAW files—and this is preferable to waiting until post-production.

BLUE SKY *(Opposite)*
There is often a balance to be struck between reducing noise and retaining detail. Although there is still some noise in this image I didn't want to remove it entirely and risk losing the fine texture in the sculpture.

Canon EOS 1Ds MkII with 70–200mm lens (at 85mm), 1/40 sec. at f/11, ISO 200

NOISE NINJA
I use Noise Ninja (www.picturecode.com) for my noise reduction needs. This is available either as a standalone application or as a Photoshop plug-in.

Using filters

Given that RAW files can be corrected in post-production, you would think that filters wouldn't have a place in digital photography. However, there are certain filters that should be in the equipment bag of anyone who is serious about their photography.

Filter types

A filter is essentially a piece of glass, gelatin, or optical resin that can be screwed or fitted into a holder fixed to the front of a camera lens. The purpose of a filter, as the name suggests, is to filter and affect light in some way. Filters range from the dramatically garish to the very subtle, and not all filters are indispensable: some are fun for a while, but the appeal fades quickly.

There are two schools of thought with filters. Some photographers like the idea that an image is very obviously filtered, while others prefer filters to be used to achieve a more naturalistic effect—if you can tell that a filter has been used, then the image has "failed" in their eyes. Which you subscribe to is entirely up to you.

Most filters are available in screw-in form, which means they screw into the filter thread at the front of a lens. Generally screw-in filters are cheaper than those designed to slot into a filter holder, but a big drawback is that there is no one standard filter thread size. If you have a variety of lenses you may find that a particular filter only fits onto one lens. Therefore, if you buy a screw-in filter it is a good idea to buy it for the lens with the biggest filter thread size and then purchase stepping rings to convert the

filter to your other (smaller diameter) lenses.

The alternative to screw-fit filters is a filter "system." This consists of a filter holder that clips to an adapter ring screwed to the front of a lens. If your lenses have different filter thread sizes you would buy an adapter ring for each lens, but you can use the same filter holder on each. Square or rectangular filters can then be slotted into the holder. Cokin, Hi-Tech, and Lee are well-known manufacturers of filter holder systems and the advantage is that a single filter holder and set of filters can be used on all of your lenses. The disadvantage is that once you've bought a system you may be locked into buying that manufacturer's filters, limiting your filter choice.

UV or skylight

These filters reduce atmospheric haze and the over-blueness in images that can be caused by high levels of ultraviolet light. A skylight filter is slightly "warmer" than a UV filter, and adds a subtle pinkness to an image (although this may be cancelled out if your camera is set to automatic white balance).

Both UV and skylight filters are effectively transparent, so they do not affect exposure.

For this reason, some photographers leave a UV filter attached to their lenses at all times, to protect the front lens element. However, as filters tend not to be optically coated there is a small increase in the risk of flare.

Polarizing filters

When light hits a non-metallic surface it bounces off and is scattered in all directions—it has become polarized. This reduces the color saturation of the surface and with glass and water this scattering causes a reduction in the transparency of the material.

A polarizing filter cuts out polarized light perpendicular to the axis of the filter, helping to boost color saturation, or, with glass and water, to increase transparency. Polarizers work best when they are at approximately 35 degrees to the surface, and do not work at all when they are at an angle of 90 degrees.

Another use for a polarizing filter is to deepen the color of a blue sky. This is most effective when the polarizer is used at 90 degrees to the sun, with the effect diminishing as you move away from this angle. The height of the sun also affects how strongly the polarizing filter appears to work, while the strength of the polarizing effect is varied by rotating the filter around the lens axis.

Polarizing filters come in two types, circular or linear. This does not refer to the shape, but is a description of how the polarizer was made. Linear polarizing filters can affect a camera's autofocus system so, for that reason, most photographers should buy a circular polarizer.

Neutral density filters

The minimum ISO value on most cameras is ISO 100, which is fine for everyday use. However, there are times when a slower ISO would be useful—perhaps if you want to use a longer shutter speed for creative effect. In this instance, photographers use neutral density (ND) filters to artificially lower the ISO.

ND filters are available in different strengths, and reduce the amount of light reaching the

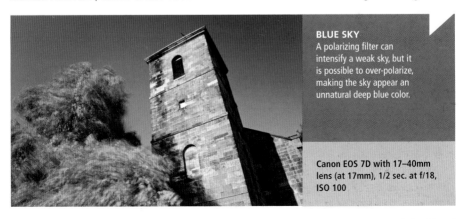

BLUE SKY
A polarizing filter can intensify a weak sky, but it is possible to over-polarize, making the sky appear an unnatural deep blue color.

Canon EOS 7D with 17–40mm lens (at 17mm), 1/2 sec. at f/18, ISO 100

sensor. As the name suggests, they are neutral in color, so do not affect the color balance of the image. Using a 1-stop ND filter is the equivalent of switching your camera from ISO 100 to ISO 50, a 2-stop ND filter is equivalent to reducing the ISO from ISO 100 to ISO 25, and so on. If the suggested shutter speed is 1/60 sec., for example, but you'd rather use 1/8 sec., without altering the aperture, you would need to use a 3-stop ND filter.

An ND graduate filter is a variant of ND filter that has a transparent bottom half and a filtered top half. It is used when one portion of an image is far brighter than the rest, and the dynamic range exceeds what the camera is capable of recording. Landscape photographers often use ND graduate filters to balance a bright sky with a darker foreground. As with plain ND filters, ND graduates are available in different strengths, and the greater the difference in exposure between the two parts of a scene, the stronger the ND graduate you would use. Although ND graduates are available in screw-in

form, they work best when used with a filter holder so they can be moved up and down (or rotated) so that they can be positioned precisely.

Notes

A polarizer cuts out approximately 2 stops of light when it is used at maximum strength, so can be used as an alternative to an ND filter.

ND filters are often sold using an optical density figure: a 1-stop ND filter has an optical density of 0.3; a 2-stop ND filter is 0.6; and a 3-stop ND filter is 0.9.

MULTIPLE FILTERS *(Opposite)*
Some shooting situations require the use of multiple filters. In this instance I used a polarizer to help deepen the blue of the sky and a 1-stop ND graduate to help balance the exposure between the two halves of the image.

Canon 7D with 17–40mm lens (at 17mm), 1/80 sec. at f/10, ISO 200

LONG EXPOSURE
I wanted an exposure that could be measured in whole seconds for this coastal scene. To achieve this I had to use a 10-stop ND filter.

Canon EOS 7D with 17–40mm lens (at 21mm), 60 sec. at f/22, ISO 100

White balance

Light is rarely pure "white" and usually has a subtle color tint. Cameras are objective recording devices that easily pick up this tinting, even though we may not necessarily perceive it.

The Kelvin scale

The most familiar light source in nature is the sun. At noon, when the sun is at its highest in the sky, the light is a relatively "cool" blue. However, at the ends of the day, sunlight "warms up" and becomes more orange-red in color. This change of color is known as a shift in the color temperature of the light, and color temperature is measured using degrees Kelvin (K).

The Kelvin scale is based on a theoretical object called a "black body radiator." It is so black that no light is reflected from its surface, which makes it a perfect emitter of thermal radiation. Scientists have postulated that as this black body radiator is heated up it begins to change color. At 3,200K, it would be glowing yellow-orange and as the temperature rises, the color continues to change, becoming an intense blue by 10,000K.

The colors—and the temperature at which those colors are emitted by the black body radiator— are used as a scale to describe the color temperature of light. So, for example, light from a flash is approximately 5,500K.

Notes

Film photographers would use a film balanced for either daylight or tungsten (bulb) lighting. A further refinement to color balance would be made by using color filters.

White balance corrects an image by applying the opposite color. A digital image will be very cool if you are shooting in daylight, but have set your camera's white balance to 2,800K. This is because you are telling your camera to compensate for a light source with a color temperature of 2,800K, which requires the addition of blue.

| 1,000K | 2,000K | 3,000K | 4,000K | 5,000K | 6,000K | 7,000K | 8,000K | 9,000K | 10,000K |

COLOR TEMPERATURE
A representation of the Kelvin scale. The blue at 10,000K is approximately that of blue sky.

Camera white balance

Because light sources aren't necessarily neutral in color they can cause an unexpected color cast to appear in your images. To correct this, a process called white balancing is used.

If you have a sheet of white card, illuminated by an ordinary household bulb, it will look white to your eyes. However, take a photo of the white card without setting the white balance and it will probably be recorded as a pale orange. This is because the light from a household bulb is very warm (approximately 2,800K on the Kelvin scale). Your camera's white balance electronically corrects for this tinting, restoring the sheet of card to white.

Digital cameras usually have a series of presets for different lighting types, as illustrated in the grid below. Most digital cameras also have an auto white balance option, which is where the camera "guesses" the right amount of correction to apply. Generally, this works well, but for greater precision it is better to create a custom white balance setting for the light that you are working in.

Whichever setting you use, the white balance is recorded in the RAW file metadata, but it is not permanent—your RAW conversion software will allow you to amend the white balance in post-production, either using presets or by setting a particular Kelvin value.

Symbol	Description	Kelvin temperature
	Tungsten. "Cools" the orange-red cast of incandescent household light bulbs.	2,800–3,200K
	Fluorescent. Not as "warm" as incandescent bulbs, but still far warmer than daylight.	4,000K
	Daylight. This is for midday sunlight, when the light is relatively neutral.	5,000–5,500K
	Flash light. Very similar to the color temperature of daylight, so is referred to as daylight-balanced.	5,500K
	Overcast/Cloudy. "Warms up" the cool light of overcast days.	6,500K
	Open shade. Shadows outdoors are softly illuminated by blue sky, making the light quite cool.	7,500K
	Custom white balance.	User-defined

Custom white balance

In many respects there is no right answer to how white balance should be set. What's important is how you want your images to look—you may prefer to have your images slightly warmer or cooler than is strictly accurate. Color does have an effect on the impact of an image, though, and cooler colors are often associated with emotional detachment

and sadness. More positively they are seen as calming and efficient. Conversely, warmer colors are more aggressive and irrational, as well as more romantic and lively.

During post-production there's no reason why you shouldn't tweak the white balance of your RAW images to convey a particular mood. There are also some situations that you probably wouldn't want to correct—the light from sunrise or sunset is very "warm," for example, and while it would be possible to correct the white balance so that it was closer to "daylight" this would remove the atmosphere of the image.

It is possible to adjust the color balance in post-production until it matches your recollection of a scene, but a more precise approach is to create a custom white balance at the time of shooting. Cameras vary as to how this is achieved, but generally it involves shooting an image of a white surface in the same light as your subject. The surface should fill the frame so that no other colors affect the white balance reading. This test image is then selected as the target when setting your custom white balance. When you move out of the light used when setting the custom white balance you must go through the same process or use one of your camera's white balance presets.

FACES
Portraits of people often benefit from a slight warmth overall—a cool color balance can make your subject appear ill.

Canon EOS 5D with 100mm lens, 1/1600 sec. at f/3.5, ISO 100

WHITE BALANCE *(Opposite)*
These four images have been converted using different white balance settings in Lightroom. Top left: 2,800K. Top right: 4,000K. Bottom left: 4,800K. Bottom right: 7,500K. Of the four, my preference is for the image bottom left.

Canon EOS 7D with 70–200mm lens (at 80mm), 1.6 sec. at f/18, ISO 100

ExpoDisc

One problem with using a white surface to create a custom white balance is finding something in the scene to measure from, or carrying and using a piece of card for the purpose. The ExpoDisc, by Expolmaging, is a neat solution to this problem. The ExpoDisc fits onto the front of your lens and allows you to take an incident reading of the light to create a custom white balance image. As with screw-in filters, the ExpoDisc is available in different thread sizes.

BLUE
This RGB histogram of an image of my graycard shows that the white balance is too cool.

JUST RIGHT
Setting a custom white balance makes the image (and resulting histogram) more neutral in color.

RGB histogram

If your camera can display an RGB histogram you can use this to assess whether your custom white balance profile is correct. As with setting a custom white balance, you need to shoot a photo of a neutrally colored surface (the graycard included with this book would be ideal). When you look at the histogram of this image, if the various peaks and troughs of the RGB histogram are in general alignment, the white balance is correct. If one of the RGB channels is shifted more to the right than the other two then the white balance is incorrect. If, for example, the red channel is shifted more to the right than the blue and green then the image is perhaps warmer than it should be.

LIGHTHOUSE (Opposite)
Some images will be less atmospheric if the color is corrected fully. This scene, with no direct sunlight, was very blue. I could warm it up, but this would be a mistake—for me, the coolness, coupled with the splash of salmon pink on the horizon, is an appealing combination.

Canon EOS 7D with 17–40mm lens (at 17mm), 8 sec. at f/13, ISO 100

EXPODISC
www.expoimaging.com

High dynamic range

The dynamic range of a digital camera sensor is far more restricted than the human eye. High dynamic range (or HDR) imaging is one way of overcoming this limitation by merging images exposed for different parts of the tonal range.

Shooting for HDR

The basic idea of creating an HDR image is to take multiple shots of the same scene using different exposure settings for each. A typical method is to shoot three images: one exposure for the shadow areas of the scene, a "normal" exposure, and one exposure that retains detail in the highlights. This can be achieved either by bracketing or by using exposure compensation.

One limitation of the HDR technique is that each image should be exactly the same (apart from the exposure). Anything that moves in the scene between the different shots can create unusual artifacts when the images are later merged, so for this reason it is a good idea to use a tripod so that the camera is stationary between shots.

Once you have your three (or more) images, they are imported into HDR software: Photoshop has an HDR option, while third-party software such as Photomatix Pro is a viable alternative. The options for blending your images will vary between different software packages, but you should be offered the ability to choose how the final HDR image is created. Different HDR methods produce different results and the most suitable will vary from image to image.

Although shooting multiple exposures will give you the best results, it is perfectly feasible to vary the exposure of one RAW image and export these variations to create an HDR image. This is often the only way to cope with a scene in which there is movement. Because you will be varying the exposure in post-production—increasing the risk of noise—it is better to use an image that has been exposed to the right.

Why not try?

The Enfuse plug-in for Adobe Lightroom (www.photographers-toolbox.com) allows you to combine multiple exposures.

BRACKETING *(Opposite)*
Three images were shot using exposure bracketing set to ±1⅔ stops. The merged result can be seen in the main image on the opposite page.

Black and white

Creating black-and-white images from RAW files happens at the post-production stage, but planning at the shooting stage will make this task much easier.

Seeing in black and white

There is more to creating a black-and-white (or "monochrome") image than simply removing the color. The image of the cube on this page is composed of the three primary colors, red, green, and blue. In color, red, green, and blue are very different, but desaturating the image converts the three colors into the same mid-gray tone. This is because primary red, green, and blue have the same reflectivity.

What is needed is some way to control how colors are converted to black and white. When shooting with black-and-white film this is achieved by using colored filters that let through the wavelengths of light that are similar to the color of the filter, and reduce, or block entirely, those wavelengths that are dissimilar. So, a red filter would let through red wavelengths of

light, but block blue ones. This has the effect of lightening anything red in an image and darkening anything blue, separating the tones and making for a far more interesting image.

Although you could use colored filters when shooting digitally, a better option is to simulate them in your RAW conversion software. This will give you more choice as to how an image is converted into black and white, as you will be able to mix the "strength" of the various colored filters for effect.

CUBE
Simply desaturating the color cube (below) produces one overall gray tone. The cube on the right was converted to black and white by mimicking a red filter. The red face is lightened the most; the blue face is almost black.

Shooting for black and white

Most cameras have a black-and-white option when shooting JPEGs, and some are even able to mimic shooting with colored filters. These options will be in the shooting menu (or similar). Shooting in black and white with JPEG is permanent—you cannot add the color back once the image has been saved to the memory card (although you can, of course, reset the camera to shoot color from that point on).

Activating your camera's black-and-white mode will also have an effect on RAW files. If you use the RAW conversion software that came with your camera, then these black-and-white settings will be used when you import your RAW files, but unlike a JPEG, these settings aren't permanent. Instead, they are just an initial starting point in the RAW file conversion process, and you can revert to a full-color image by changing the relevant color option in the RAW software.

Personally, I often shoot RAW+JPEG when I am working in black and white, with the camera's picture style set to black and white and the "filter" option on the camera set appropriately. I then use the JPEG files as a very quick guide to show me how the RAW files could be converted to black and white. Once I've finished the RAW conversion, the JPEG files are discarded.

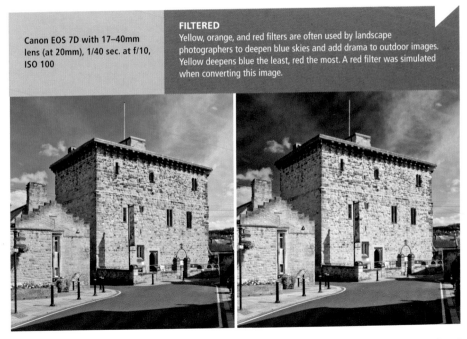

Canon EOS 7D with 17–40mm lens (at 20mm), 1/40 sec. at f/10, ISO 100

FILTERED
Yellow, orange, and red filters are often used by landscape photographers to deepen blue skies and add drama to outdoor images. Yellow deepens blue the least, red the most. A red filter was simulated when converting this image.

By focusing precisely and using a wide aperture, you can minimize the depth of field and emphasize the most important elements of an image. For this photograph I used a long focal length lens, focused on the second face in, and set the aperture to f/4. As the face is the only truly sharp part of the picture, the viewer's eye is immediately drawn to it.

Camera: Canon EOS 7D
Lens: 70–200mm lens (at 120mm)
Exposure: 8 sec. at f/4
ISO: 100

Shutter speed

The faster your subject is moving, the faster the shutter speed will need to be if you want to "freeze" the action. Even on bright days this may mean using a wide aperture or a high ISO setting. The flag in this photo was moving quickly, thanks to a strong breeze, so I set the camera to continuous shooting with a fast shutter speed, capturing several photos in sequence. Later I chose the photo with the most pleasing flag, and discarded the rest.

Camera: Canon
EOS 7D
Lens: 70–200mm lens
(at 100mm)
Exposure: 1/3200 sec.
at f/4
ISO: 400

Introduction

You have plenty of space on your memory card and an itchy trigger finger, so what's to stop you from filling the card with images and worrying about the consequences later?

This chapter is about workflow. It will cover the ways in which you can deal with your RAW files during the importing process, including naming conventions and keywording. However, the efficiency of your RAW workflow begins long before you sit down at your computer.

Unlike shooting on film, each digital image that you shoot is "free," so it is very tempting to adopt a "shoot anything and everything" approach and in doing so amass hundreds or thousands of images. If you do this, though, you will quickly discover that there is a cost involved: not a financial cost, but a *time* cost.

Each RAW image that you shoot will need to be assessed, processed, and then saved in post-production. This takes time if you do it properly.

Although certain operations can be automated, you could still find yourself overwhelmed by the amount of work that needs to be done.

Therefore, a more parsimonious and thoughtful approach to shooting will pay dividends in the long term. Not only will you need to spend less time processing your files, but you will likely find your photography improving more quickly. Try to imagine that each image you shoot has a financial penalty, and before you press the shutter button, decide whether you'd be prepared to pay that price. If you wouldn't, then ask yourself why not. If the truthful answer is that the image isn't good enough to justify the penalty, then you should reconsider pressing the shutter-release button.

BRIDGE TOO FAR
I broke my own rules with this scene, shooting multiple variations to try and capture the right amount of traffic crossing the bridge.

Canon EOS 1Ds MkII with 17–40mm lens (at 30mm), 1/2 sec. at f/11, ISO 100

COGS *(Opposite)*
A good RAW workflow should be efficient, like a well-oiled machine.

Canon EOS 7D with 50mm lens, 1/60 sec. at f/1.6, ISO 800

Workflow

Developing a RAW workflow is very much a personal choice and there is no single right answer. On the opposite page is a chart that illustrates my personal workflow, from the initial importing of the RAW files through to the output of the image as either a print or to a web site.

Although it looks like a long list, some of the tasks are automated and others are completed relatively quickly because I am familiar with the software I use. That doesn't mean that I am not open to new ideas: any application that has the potential to speed up one part of the workflow will be carefully assessed and integrated if it is suitable.

Importing RAW files

Your first task once you return home with your memory card of images is to import them to your computer. Good RAW conversion software should automate this process for you, allowing you to specify where the image should be imported to, what—if any—keywords should be added to the metadata, and whether any process (such as conversion to DNG) should be applied to the files as they are imported. Adobe Lightroom falls into this category.

If your RAW conversion software doesn't do this for you, you will have to copy the files manually. Your computer may well offer to do this for you when you first plug the memory card into your USB reader. If this is the case, just follow the instructions on screen. There may be options to rename the files during this process, in which case use the file naming convention you have chosen.

If your computer does not offer to import your files automatically, then double-click on the memory card drive icon on the desktop. Double-click on the DCIM folder, and then on the specific camera folder. Select the RAW files you want to import, right-click, and choose *Copy...* from the menu. Navigate to the folder you want to import to, right-click, and select *Paste...*

CARD READER
Unless you connect your camera directly to your computer, a memory card reader is a vital piece of equipment. I use a multi-card reader as I use a variety of cameras that use different memory card types. Kingston USB 3.0 Media Reader.

Task	Sub-tasks
Importing	Initial import of images to computer
	Rename
	Back up
	Assess and rate
Editing	Reduce sharpening to minimum
	Set camera profile
	Rotate, straighten, or crop as required
	Correct for lens distortion and chromatic aberration
	Clean up dust spots or blemishes
	Noise reduction
	Apply white balance corrections
	Adjust exposure if required
	Basic image adjustments° such as contrast
	Advanced image adjustments such as conversion to black and white
Export	Export as 16-bit TIFF
	Load image into Photoshop
	Final image adjustments
	Convert to 8-Bit and save to appropriate folder
	Update digital asset management database
Printing	Open and duplicate image
	Resize duplicate as required
	Sharpen duplicate as required
	Print
	Close duplicate without saving
Web use	Open and duplicate image
	Resize duplicate as required
	Sharpen
	Apply identification watermark
	Convert to sRGB
	Save as JPEG with relevant file name
	Upload to target web site
	Delete JPEG

Backing up

Your images are an investment in time and effort, so it makes sense to take care of them. Your computer's hard drive is a mechanical device, and, although hard drives are very reliable, it may fail without warning. For this reason it is important that your images are backed up on a regular basis.

If your image collection is relatively small they could be burned to a CD or DVD, but this should only be seen as a temporary solution as optical media can corrode over time. A better solution is to copy your computer's hard drive to an external hard drive, and continue to make regular back-ups. For more security use two hard drives and if possible keep one at a friend or relative's house and then swap them over at least once a week.

To make the back-up process less painful, it pays to use back-up software rather than dragging and dropping files between hard drives. Good back-up software should be smart enough to know when a file hasn't altered between back-ups, so that only new files are copied over to the external hard drive. This facility can reduce the time taken to back-up a hard drive by a considerable factor.

SECURITY
Backing up your computer's hard drive should be an integral part of your workflow.

Copy [Macintosh HD] to [mungo]

using [Backup – all files]

1. Prepare to Copy Files

✓ Prepared Macintosh HD
✓ Prepared mungo
✓ Preserved Spotlight state on mungo

2. Copy Files

→ Copying files from Macintosh HD to mungo using Smart Update
269,873 of 730,757 files evaluated, 1,607 files copied. Effective copy speed 28.50 MB/s.
11.44 GB evaluated, 6.22 GB already up to date, 280.90 MB copied.

3. After Successful Copy

• Make mungo bootable
• Update prebinding on mungo
• Restore Spotlight state on mungo

[Stop]

Registered to: David Taylor Elapsed time: 03:50

The ultimate external back-up drive is a RAID (Redundant Array of Inexpensive Disks). This is a device that has a number of hard drives built into it. Data copied to the RAID is divided and duplicated across the hard drives so that if one fails the data can still be extracted from one of the good hard drives. The greater the number of hard drives in the RAID the more secure the system. Your computer should make the use of the RAID transparent so you don't have to worry about how the data is distributed across the system.

The next big revolution is Cloud computing and several companies already offer online image-storage services. This has the advantage that your images are stored off-site and so are less vulnerable to hard drive failure (though of course you have to rely on your chosen storage service to have a stringent back-up policy). You will also have access to your images wherever you are in the world, just as long as you have a Wi-Fi connection.

Why not try?

Mac OS has back-up software called Time Machine built in. This application can be set to automatically back-up your hard drive at regular intervals. Super Duper is a third-party alternative.

Windows 7 comes with the Backup and Restore application, while Hyper-V is a commercial alternative.

RAID
LaCie 2big USB 3.0.

Camera: Canon EOS 7D
Lens: 17–40mm lens
(at 23mm)
Exposure: 1/125 sec. at f/11
ISO: 250

EDITING

It is very tempting to shoot as many images as you can when you are out on assignment. However, this often results in a lot of very similar pictures, which require more time to look through, assess, and edit. A more considered approach during shooting will result in fewer, but ultimately much stronger images.

Camera: Canon EOS 7D
Lens: 50mm lens
Exposure: 1/250 sec. at f/2.8
ISO: 500

DETAILS

When out on assignment I try to shoot a mix of images. Some, such as the image on the opposite page, show the "bigger" picture, but it is important to cover all aspects of a location. I therefore often shoot details—such as this hand testing sheep's wool—to help tell the full story.

File naming

Each time an image is created, your camera assigns it a file name. However, it is a good idea to rename your files to something more useful either during the import process or during editing. A big problem with the assigned camera file name is that one part of it will be a number. This number increases by one for each image subsequently shot. This is so that the camera can keep track of how many images are on the memory card and in what order they were shot. Most cameras only use four digits for these numbers, so when 9999 is reached the camera restarts with 0001. This means that if you shoot more than ten thousand images you will begin to have images with the same file name.

The key is to use a file naming convention that is infinitely expandable, without repeating, but that is also comprehensible to you. The system I use is to split the file name into two halves. The first half represents the year and the month the image was shot, so 1208 would be 2012 and August. The year is first so that when images are sorted by file name the most recent appear at the top of the list.

The second half is a four-digit number as a count of the images shot in that month. I use four digits as I've never shot more than 9999 images in one month, but if I did, I could easily use five, six, or seven digits. This system is not perfect and it will eventually repeat—in 2100 I'll have two images with the file names 0001_0001 (the other being from the year 2000)—but I'll worry about that when the time comes!

0001_0001
In January, 2100, I'll have two images with the same file name—0001_0001. Exposure details unrecorded.

Keeping track

If you've just imported your first RAW file, congratulations! Create a RAW file folder and put it in there. Now keep adding your RAW files to the same folder and eventually you'll have… a folder with thousands and thousands of files in it. Try and find a specific image and you'll find it an impossible task.

As with file naming, creating a good, expandable filing system is important if you want to keep track of your image collection. There are many possible ways to do this and, in many respects, as long as you know how your system works everything should be fine. The problems may start when someone else needs to sort through your images. It is then that a logical system saves time and patience.

The system I use is to divide my photos into categories. I create a master folder for each category within my RAW files folder— "Architecture" for instance. I then create a subfolder to refine the category, such as "United Kingdom." I keep adding subfolders so that the categories become more and more specific.

Eventually, images are moved to the relevant subfolders depending on how I've categorized them. So, images of Hexham Abbey in my hometown would be found in Architecture>United Kingdom>England> Northumberland>Hexham>Abbey. I could subdivide the Abbey folder still further if there were specific details that I had multiple shots of, such as Exterior and Interior.

FILED AWAY
Because every one of my images is categorized I can find a specific one quickly and easily.

When I convert the RAW files to JPEGs or TIFF I use a mirror of this folder system to store those files, so I have two folders—Photography RAW and Photography Converted—each with the same subfolder structure. Keeping my RAW files and my converted files separate like this means that I don't see the same files twice in my digital asset management software.

Digital asset management

What we have discussed so far is known as "digital asset management" (or DAM), which essentially means having a system in place so that you can keep track of all your image files. Although RAW conversion software such as Lightroom will maintain a catalog of your images, there is still a place for a standalone program dedicated to digital asset management.

At its most basic, a DAM application is a database of images. Good DAM software should allow you to quickly search for images (either by file name or by keywords read from image metadata), sort your images based on different criteria, and allow you to apply labels or ratings so that you can group images temporarily or permanently as required.

Some DAM software now supports facial recognition, which, once the software has learned a particular face, can be used as a search criterion for images. There are several packages available for both Windows and Mac, ranging from comparatively simple and free software, to commercial packages.

PICASA
Free-to-use DAM software with basic RAW editing tools.

Assessing your files

Once you've imported your files and backed them up, it is time to assess them for quality. Whether you delete failures entirely is up to you, but if an image is technically deficient there is a strong case for deleting it immediately.

Images that you are esthetically unsure about are another matter entirely. It's all too easy to make snap judgements about images, with some standing out as being the best of the batch, but there may be more subtle images that don't appeal immediately. Those are the images that should be left alone initially. My practice is not to edit the images from a shooting session for a few days if possible. This allows me to think more carefully about which images work and which ones don't. Sometimes it is actually the "quieter" images that become my favorites after this time of reflection.

Why not try?
If you rotate an image through 180° and the composition still looks balanced, you have a winner. If it doesn't, you can generally see why more quickly.

BADGER
This was a "throwaway" shot that gradually appealed more and more the longer I "lived" with it.

Canon EOS 7D with 50mm lens, 2 sec. at f/5.6, ISO 100

Keywords

Try to be as comprehensive with your keywords as possible. For this image I initially added geographical details about the location, from the specific area, all the way to the country and even the continent. Next came keywords that noted the time of day. I then added keywords describing the flora in the foreground. Finally, I added more descriptive keywords that reflected the mood of the image—calm, peaceful, and so on.

Camera: **Canon EOS 7D**
Lens: **17–40mm lens (at 24mm)**
Exposure: **1/10 sec. at f/7.1**
ISO: **100**

Making notes

If I'm away for extended periods on a photo trip, I always make notes as I'm working. These notes include date, location, and any other information that may be useful, all linked to the relevant file names of the images shot. This makes the job of keywording images far easier and is more accurate than relying on memory.

Camera: Canon EOS 1Ds MkII
Lens: 70–200mm lens (at 120mm)
Exposure: 30 sec. at f/9
ISO: 100

CHAPTER 5 ADOBE CAMERA RAW

Introduction

If you intend to use Photoshop to edit your RAW images, Adobe Camera Raw is the first stage in that process. In fact, it is almost possible to take an image to completion in Adobe Camera Raw and just use Photoshop for a final polish.

Adobe Camera Raw (ACR) has come a long way since its initial incarnation. Then, only a few adjustments could be made to a RAW file before it was imported into Photoshop, and only a handful of cameras were supported (although, to be fair, only a handful of cameras were available). Now, having reached version 6.5, ACR's repertoire has expanded and the list of cameras supported is comprehensive.

What makes ACR so amazing is that Adobe does not get any support from the camera manufacturers. Every time a new camera is released Adobe's engineers have to go to work and take apart the RAW file to get ACR to recognize it. So, if your new camera isn't

supported by ACR there is a good reason why it isn't, but don't worry, it will be at some point.

The one slightly frustrating aspect of ACR is that the most up-to-date versions only work with the latest versions of Photoshop: Adobe CS3 won't run ACR 6.5, for example. This means that you can't open a newer proprietary RAW file that is not supported by an older version of ACR. The way round that is to convert you RAW file to DNG, which will be compatible.

Unfortunately, there isn't space in this book to go through every option in ACR—that's the subject for an entire book! However, this chapter should give you some idea of what this comprehensive plug-in can do.

BLACK AND WHITE *(Opposite)*
ACR has options to create any photographic style imaginable.

Canon EOS 7D with 17–40mm lens (at 22mm), 1.6 sec. at f/18, ISO 100

ACR INTERFACE
The ACR interface conforms to Adobe's usual uncluttered style.

1	Filmstrip	14	RAW Settings menu
2	Zoom and Hand tools	15	Warning (when image uses pre-ACR 6.3 settings—clicking updates the image)
3	Color Adjustment tools		
4	Crop and Straighten image	16	Apply changes to the RAW file without opening in Photoshop
5	Localized adjustment tools		
6	Preferences	17	Cancel changes
7	Rotate image	18	Open image(s) in Photoshop
8	Delete image	19	Image select (in Filmstrip mode)
9	Turn preview changes on/off	20	Workflow options
10	Toggle full screen mode	21	Zoom levels
11	Image histogram	22	Save image
12	Camera information	23	Toggle filmstrip
13	Image adjustment tabs	24	Preview image

Using Adobe Camera Raw

If you've used Adobe software before, you'll feel right at home with Adobe Camera Raw: the interface is very similar to other Adobe products and many of the shortcut keys are exactly the same.

When you open a RAW file with Photoshop (or through Adobe Bridge) the ACR interface will be displayed. If you're happy to bypass ACR's adjustment tools, click on the *Open Image* button at the bottom of the dialog box. The RAW file will then open in Photoshop (if you hold down Shift as you click, the image will open as a Smart Object in Photoshop, or, if you hold down Alt, the image will open without adjusting the Metadata in the RAW file).

After making all of your adjustments you can then choose to either *Open Image* (in Photoshop) or, if you're not ready to continue, click on *Done* and the alterations will be saved and ACR will close. If you want to exit ACR without saving any of your adjustments, choose *Cancel*.

If you are using your camera's proprietary RAW files and you make adjustments in ACR, these adjustments are not saved to the RAW file. Instead, when you click on *Open Image* or *Done*, an XMP sidecar file is created in the same folder as the RAW file. The next time you launch ACR it reads this XMP file and applies the saved settings to your image. Any adjustments you make when using DNG are saved directly to the file, rather than to an XMP file. Finally, you can save the RAW image as another file type using *Save Image*.

Note

As in Photoshop, you can undo adjustments in ACR by pressing Ctrl+Z (Windows) or Cmd+Z (Mac). To go back further than one undo, press Alt at the same time.

SAVE IMAGE
Dialog box with save options.

Zooming and panning

At the bottom left of the ACR window, below the preview image, is a small pop-up menu with a series of magnification or zoom presets. Choosing a preset allows you to zoom in or out of the RAW image. At 100%, one pixel on your monitor equals one pixel in the image. Selecting *Fit in View* will force ACR to display the entire image as best it can within the image preview window. Using the plus or minus buttons to the left of the pop-up menu also allows you to zoom in and out.

Selecting the Zoom tool is arguably a quicker way to achieve the same thing. The default is set so that you zoom into the image (the mouse pointer is a magnifying glass with a + in the middle). Clicking anywhere within your image will cause ACR to zoom in at that point. To zoom out, hold down Alt as you click. Clicking and dragging will define a zoom box and, once you release the mouse button, ACR will zoom in and display that area within the preview image window.

There will be times when your RAW image fills the preview window, so some of the image is not visible. At this point you can use the Hand tool to move your image around the preview window: select the Hand tool and click and drag the image.

White Balance

To make very quick color corrections, select the White Balance tool. When you click on an area in your image the tool will analyze the color of the pixel you clicked on and, if it has a color tint, ACR will adjust the white balance to compensate. For that reason, always click on an area of your image that you know should be neutral gray. If you click on an area that should be colored, you will get an inaccurate white balance correction.

Note

If you hold down the spacebar when another tool is selected, the tool will temporarily change to the Hand tool, allowing you to pan around your image as above. When you release the spacebar your original tool will be restored.

Color sampler

When you click in your RAW image with the Sampler tool, the RGB values of the pixel you clicked on are displayed. You can set up to nine sample points within your image. To remove an individual sample point click on it again holding down Alt (Windows) or Cmd (Mac). To remove all sample points, click *Clear Samplers*.

Target

The Target tool allows you to make adjustments to an image by clicking directly in the image preview window. Click on the Target tool icon and select the adjustment option from the pop-up menu. You can choose to adjust the Parametric Curve, the Hue/Saturation/ Luminance, or Grayscale Mix of the image.

To use the Target tool click and drag in the image preview window. If you have chosen *Hue/ Saturation/Luminance*, dragging your mouse to the left will decrease the HSL values, while clicking and dragging it to the right will increase them. Which of the HSL sliders is activated will depend on the color of the pixel where you made the initial mouse click. If you click on a red pixel and have *Saturation* selected, for example, only the red pixels in the image will be affected. When *Parametric Curve* is selected, the shadows, midtones, or highlights are adjusted, again depending on the value of the pixel that you initially clicked on.

LION
Color sampler is a very quick and easy way to measure whether neutral grays in your image are indeed neutral. If not, color sampler will also give you a clue as to how much white balance adjustment needs to be made.

Canon 1Ds MkII with 50mm lens, 1/250 sec. at f/7.1, ISO 100

Crop

Just because you've shot an image with a particular composition doesn't mean that you can't refine the composition in post-production. One of the ways to do this is to crop your image. This can either involve retaining the same basic shape of the image but using a smaller area, or changing the shape entirely and using a square format, for example.

With the Crop tool selected, click and drag within your image. The area inside the box you've drawn is the crop area. If you want to resize the crop area, click and drag the boundaries of the box. If you want to rotate the crop area, click and drag with the mouse pointer in the gray area outside the crop box. Press Enter (Windows) or Return (Mac) to crop the image. If you have used the rotate option, the image will be rotated as well.

Click on the Crop tool icon to select the options to constrain the proportions of the crop box. Selecting *1 to 1*, for example, will constrain the crop box to a square. Select *Clear Crop* to reset your image back to its original size.

Straighten

Getting your subject straight in-camera isn't always achieved accurately, but the Straighten tool will help you correct this. To use the tool, select it, click and drag a line along part of the image that you would like to be straight (the horizon, for example), and then press Enter (Windows) or Return (Mac). The image is rotated so the line you've drawn is parallel to either the top or sides of your image.

CROP
Selecting and rotating the crop area (top) and the result (bottom).

Rotate

Turns your image 90 degrees clockwise or counterclockwise.

Spot Removal

The Spot Removal tool is designed to simplify the task of removing dust spots and blemishes in your RAW image. The tool works by using two circles connected by a line. The first circle (drawn where you initially click your mouse) is the target area that needs repairing, while the second circle is the area of your image that is sampled to "patch" the repair.

Selecting *Clone* from the Spot Removal pop-up menu will replicate the sampled area exactly, while *Heal* attempts to match the texture, tone, and shading to make the repair appear more natural. *Opacity* alters the transparency of the repair: set to 100 the repair is completely visible, at 0 it is completely transparent.

With the Spot Removal tool selected, click and drag on the area you wish to repair. As you do so, the *Radius* of the repair circle increases (the *Radius* can also be altered using the slider on the Spot Removal panel to the right of the image preview window). When you release the mouse button, the repair circle will be drawn. You can move either the target or repair circle by clicking with the mouse pointer inside the circle and dragging them to a new position. To delete a selection, move your mouse pointer inside either circle and press *Delete*.

Red-eye

When using direct flash for portraiture, your subjects can often suffer from "red-eye." This is caused by the flash bouncing off the back of the eye and out through the iris again.

With the Red-eye tool selected, and your image at 100% zoom, drag a box around your subject's eye. ACR will analyze your image to determine how big the affected area is. You can change the size by dragging the box. Alter the *Pupil Size* by dragging the slider left or right to decrease or increase the selection respectively. Drag the *Darken* slider to darken the pupil within the selected area and the iris outside it.

Adjustment Brush

The Adjustment Brush tool allows you to make localized changes to your image that are applied by "painting" the refinements where they are needed. The Adjustment Brush offers a variety of adjustment types—Exposure, Brightness, Contrast, Saturation, Clarity, Sharpness, and Color. Dragging the sliders will decrease and increase the adjustment.

The brush option sliders allow you to customize how the adjustment brush operates. *Size* controls the size of your brush in pixels, while *Feather* controls how "soft" or "hard" the brush is, determining how quickly the adjustments fade away from where the brush is applied. *Flow* influences the speed at which the

adjustment is applied as you paint, and *Density* controls the transparency of the brush. If you check *Auto Mask* the brush strokes you make are confined to pixels of a similar color. *Show Mask* switches the mask visibility on or off.

To use the Adjustment Brush tool, move your mouse pointer over the image and you will notice a set of crosshairs at the center of the brush circle. Click to place a single adjustment brush, centered on these crosshairs, or click and drag to paint a larger area. Once you've finished, a "pin" 🔍 will show you the initial point that the adjustment was applied to. With the pin selected you can adjust the sliders to alter the level of application of the effect.

> ### Note
> The inner adjustment brush circle shows the size of the brush, while the outer dashed circle shows the extent of the feathering.

ADJUSTMENT BRUSH
Altering the exposure locally.

Camera: Canon EOS 7D
Lens: 50mm lens
Exposure: 1/125 sec.
at f/12.8
ISO: 400

EMPHASIS

The adjustment brush is a useful tool to darken down a background and help your subject stand out more. For this image I used a large adjustment brush to reduce the exposure around the central leaf by one stop. This, and careful focusing, helps to draw the viewer's eye to the leaf. Below left is the mask created by the adjustment brush.

If you begin to paint again, you continue to increase the area affected by the Adjustment Brush tool. If you want to create a new adjustment, with new settings, click on the *New* button at the top of the adjustment panel and repeat the painting process as above. A new pin will be displayed to show that you've created another adjustment. To turn pins on or off, click on *Show Pins* at the bottom of the adjustment panel. To delete an adjustment, select a pin and press *Delete*.

If you want to remove part of the adjustment brush's effect, click on *Erase* and paint over the area you've adjusted. If you want to clear all the adjustment brushes, click on *Clear All* at the bottom of the adjustment panel.

> ### Note
> *Color applies a color wash over the adjusted area: you can click on the box below the slider to select a color.*

Graduated Filter

This tool acts in a similar way to a graduated ND filter. However, it is far more useful than that, as it allows you to make other types of localized tonal adjustments as well. To use the tool, select which aspect of your image you want to adjust and then use the slider to alter the level of adjustment. The options available are the same as the adjustment brush.

To apply the graduated filter, move your mouse pointer over the preview image window. Click and drag to draw the graduated filter; the further you drag, the more subtle and attenuated the filter effect will be. The start of the filter effect is indicated by a red pin and the end is marked with a green pin.

GRADUATED FILTER
ACR offers more options than its optical namesake.

Once you've created the graduated filter you can edit it by dragging these pins to extend the length of the filter or to change the angle at which it is drawn. The graduated filter can also be moved by placing the mouse pointer (which should change to a set of crosshairs with arrow points) over the line that connects the two pins. You can then click and drag it to a new location.

As with the Adjustment Brush tool, you can continue to add more graduated filters with the same settings or, by clicking on *New*, you can add a new filter with different settings.

To delete a graduated filter, click on one of the pins and press *Delete*. If you want to clear all graduated filters click *Clear All* at the bottom of the adjustment panel. To turn the graduated filter overlays on or off, use *Show Overlay* at the bottom of the adjustment panel.

FILTER EFFECT
Before and after applying a one-stop graduated filter adjustment.

Image histogram

The histogram in ACR is an RGB histogram, showing the distribution of red, green, and blue pixels in an image. Where the histogram is white, there is a mix of all three colors. Cyan shows a mix of green and blue, yellow where red and green are mixed, and magenta where blue and red are mixed.

As you make tonal adjustments to your image, the histogram will change to reflect those changes. Click on the triangle on the upper left of the histogram and any shadow detail that is being clipped will be displayed in blue in the preview image. Click on the triangle at the upper right of the histogram and clipped highlight detail will be shown in red.

Camera information

Below and to the left of the histogram are RGB values. These values show the color of the pixel that the mouse pointer is currently over when you move it across the preview image.

This is useful if you want to assess the white balance of an image as you can move the pointer over an area of the image that is supposed to be neutral gray. If one of the RGB values is far greater or smaller than the others then the color temperature of the image needs adjusting. For example, if you pick a neutral area and the red value is 200, but green and blue are both 150, you can see that the image is potentially too warm and needs "cooling." This can be achieved by dragging the *Temperature* slider on the Basic adjustment tab to the left. To the right of the RGB values is shooting information read from the camera's EXIF metadata.

Camera: Canon EOS 7D
Lens: 17-40mm lens
(at 22mm)
Exposure: 1/400 sec. at f11
ISO: 100

CONTRAST CONTROL

For this shot I "exposed to the right" to try and retain some detail in this sculpture of an eagle. However, I visualized the final image to be high in contrast, with the eagle as a silhouette. ACR's Exposure and Contrast sliders allowed me to quickly achieve and refine this effect.

Workflow Options

A RAW file has no set resolution, sharpening, or applied color space, but ACR's Workflow Options allow you to set these parameters when the RAW file is output to Photoshop.

To set the Workflow Options, click on the underlined text below the preview image. Once the dialog box is displayed, choose the required options by clicking on the pop-up menus.

Space allows you to append the desired color space. The default is Adobe RGB, but you may wish to use ProPhoto RGB, which has a wider color gamut. However, this is less compatible with other applications, so you may find you need to convert to Adobe RGB at some point in your workflow. ColorMatch RGB and sRGB are not recommended for your initial RAW editing, although if you intend to display your images on the web you will need to convert them to sRGB when they are saved as JPEGs for this purpose.

Depth sets the bit depth of your image when it is imported into Photoshop. If you

intend to use Photoshop's image-editing tools then you should set the depth to 16 Bits/Channel.

Size allows you to resize your image. The default setting is your camera's native sensor size. Increasing the size of your image will add more pixels to the file, achieved by a process known as interpolation. Imagine you have an image that consists of two pixels, one black, the other white. If you wanted to stretch the image to three pixels you'd need to create a pixel with a value somewhere between black and white to make the stretching appear smooth. In this instance that pixel would be a mid-gray.

This is essentially what interpolation is: the creation of pixels that bridge the gaps when images are stretched. Interpolation

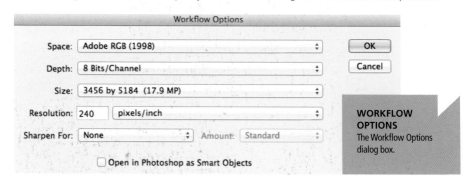

WORKFLOW OPTIONS
The Workflow Options dialog box.

does not create extra detail in your image, but it is possible to increase the size of your images considerably without too much loss of quality.

When you change the *Resolution* of your image you are not adding or removing pixels as you are when you change its size. Instead, you are changing how many pixels per inch (shortened to ppi) will be used when your image is printed. The recognized standard for printing is 300ppi. Therefore, if your image is 1500 pixels wide, and printed at a resolution of 300ppi, the printed area would physically measure five inches across (1500/300).

If you wanted a print to be ten inches across, you could set the resolution to 150ppi (1500/150), although the print quality would be lower because you are spreading 1500 pixels over twice the distance. Lower the ppi value even further—to 75ppi, for example—and a print would be 20 inches across, but with a still greater loss of quality. Fortunately, the bigger the print, the further back you have to stand to see it, so it is often possible to use a lower ppi value than the 300ppi "standard" to create large prints that still look acceptable at normal viewing distances.

Sharpen For allows you to set the sharpening for Screen, Matte Paper, or Glossy Paper, while *Amount* enables you to set how much sharpening is applied. This option is a slightly blunt instrument, which doesn't give you much control over the sharpening of your image. A better option is to sharpen in Photoshop, which has a greater number of options.

Check *Open* in *Photoshop* as *Smart Objects* if you want your RAW file to open in Photoshop as a Smart Object layer rather than as a standard Background layer.

RESOLUTION
The image above is set to 300ppi and the image to the left is set to 75ppi. Although the image to the left is bigger, this is at the expense of image quality.

Emotional response

The overall color cast of an image has an enormous influence on how we feel about it. Blue is (literally) a cool color, but it also has connotations of loneliness, emotional withdrawal, and even despair. By adjusting the color temperature of your images it is possible to alter how they are perceived. I kept the overall color cast very cool for this image, although—if it's not too fanciful—the warmer light on the horizon does offer a sense of hope.

Camera: Canon
EOS 1Ds MkII
Lens: 50mm lens
Exposure: 2 minutes at f/16
ISO: 100

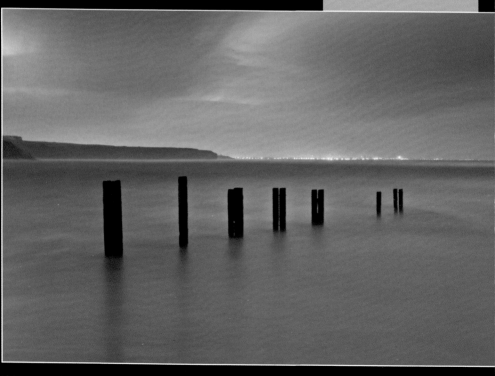

Deep shadow

Shooting a high contrast scene can be problematic. The ideal solution is to use lighting, reflectors, or filters to deal with the contrast at the time of exposure, but if this is not possible, ACR's Fill Light is a reasonable substitute. However, care must be taken to make its use appear naturalistic.

Camera: Canon EOS 7D
Lens: 50mm lens
Exposure: 1/60 sec. at f/2.2
ISO: 800

Image Adjustment Tabs

The various Image Adjustment Tabs are the core of ACR. The adjustments you can make using the various tabs range from basic adjustments, such as contrast and exposure, to more complex alterations that can correct lens distortion and chromatic aberration.

Basic

This panel is well named, as it allows you to make essential changes that begin to refine the visual quality of your images.

White balance

The initial white balance settings of your RAW file in ACR are those set by your camera (shown as *As Shot* on the White Balance pop-up menu). However, you can adjust the white balance if you wish to, by selecting a preset value from the pop-up menu. Selecting *Auto* from the pop-up menu instructs ACR to adjust the white balance of your image automatically.

Alternatively, you can use the *Temperature* slider to alter the color temperature: dragging the slider to the left increases the amount of blue in your image, making it cooler, and dragging the slider to the right increases the redness of your image, making it warmer.

Finally, if you know the precise color temperature that your image should be set to, you can type the Kelvin value into the text box to the right of the slider. The *Tint* slider below adjusts the green/magenta content of your

image. This is particularly useful if you have been shooting under fluorescent lighting, which can have a green bias (in which case you would add magenta).

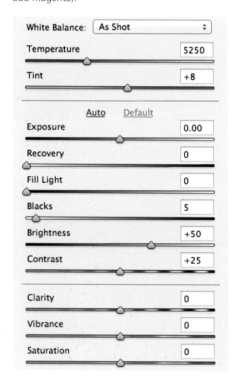

Tonal Adjustments

If you click *Auto* under Tonal Adjustments, ACR will automatically adjust the tonal range of your image. Although this will often do a reasonable job of creating a pleasing image, it should only be seen as a starting point for further refinement. Click on *Default* to restore your image to its starting point.

The *Exposure* slider is very similar to applying exposure compensation on your camera, in that a positive value will lighten an image and a negative value will darken it. ACR's *Exposure* control works in stops (again, this is similar to your camera), which means that a value of 1.0 in ACR equals 1 stop. This slider is a good first step in normalizing your image if you've exposed to the right. You can also rescue

underexposed images, although there is a risk of increasing the noise at the same time.

If the highlights in your image are slightly clipped it is possible to recover some detail by using the *Recovery* slider. *Fill Light* performs a similar function on shadow areas, lightening them without affecting pure black, and extracting detail from the shadows if any is present. Note that overuse of either option can cause unexpected tonal shifts.

Of the remaining sliders, *Blacks* increases the range of dark tones that are set to black. This will affect the shadow areas most, increasing the apparent contrast in your image.

BASIC
It doesn't take too many adjustments to start bringing a RAW file to life.

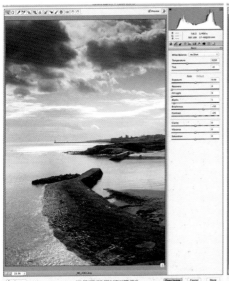

Brightness is similar to Exposure in that moving the slider to the left or right will darken or lighten your image respectively. However, unlike Exposure, the shadows and highlights are compressed, rather than eventually clipping at maximum adjustment.

Contrast, rather logically, increases or decreases the contrast of your image, affecting mainly the midtones. Pulling the slider to the right increases contrast, making dark-to-middle tones darker and lighter-to-middle tones lighter. Decreasing the contrast pulls all the tones in the image closer to an overall midtone.

Increasing the Clarity of your image increases local contrast, making your image appear sharper. However, if the setting is applied too heavily, halos can begin to appear around edge details in your image. Decreasing Clarity makes your image appear softer, which can be very effective with portraits and black-and-white images.

Vibrance and Saturation alter the vividness of the colors in your image. Pulling the sliders to the left decreases the color intensity, moving them to the right increases it. Vibrance is the subtler control of the two as it prevents colors becoming too saturated.

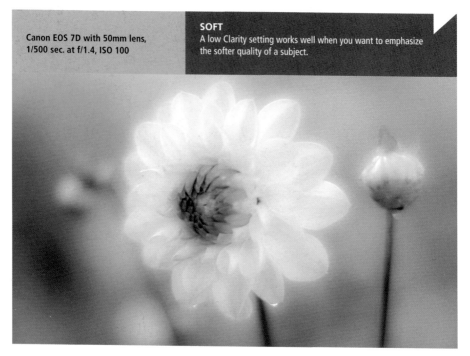

Canon EOS 7D with 50mm lens, 1/500 sec. at f/1.4, ISO 100

SOFT
A low Clarity setting works well when you want to emphasize the softer quality of a subject.

HSL/Grayscale

Vividness and Saturation are one way to give your image more punch, but the HSL/Grayscale panel helps you to refine the process. The panel has three separate tabs—Hue, Saturation, and Luminance—and on each tab is a set of sliders corresponding to specific colors. Moving a slider only affects the relevant colors in your image, so if you wanted to affect only the blues, you would move only the blue slider.

The Saturation tab allows you to increase or decrease the saturation of a specific color by moving the relevant slider to the right or left respectively. You can also type in a value of ±100 in the text box to the right of a slider,

with a minus value decreasing saturation, and a positive value increasing it. Moving the Hue sliders allows you to change one color to another—so everything purple in an image could be changed to blue or magenta, for example—and Luminance alters the brightness of colors.

Clicking on *Convert to Grayscale* converts your image into black and white. The HSL tabs will be replaced by a Grayscale Mix tab, and the sliders now act in a similar way to colored filters allowing you to change the way colors are converted into black and white. Increasing the red slider value and decreasing the blue, for example, mimics a red filter, so anything that is red in the image will be lightened and anything blue will be darkened.

Camera: Canon EOS 7D
Lens: 17–40mm lens
(at 36mm)
Exposure: 1/6 sec. at f/14
ISO: 100

NOISE

High ISO noise is generally seen more easily in areas of even tone such as a blue sky, or, as in this instance, out-of-focus areas. Using the Noise slider in ACR allows you to combat this intrusive image artifact, but the key is not to go too far: noise reduction can reduce detail in important areas of an image and result in an unnaturally smooth photograph.

Camera: Canon EOS 7D
Lens: 17–40mm lens
(at 36mm)
Exposure: 1/16 sec. at f/4
ISO: 100

RECOVERY

Subjects that are white can pose problems with exposure, particularly when there is a direct light shining on them and they have a slight sheen. Although I tried to be as careful with the exposure as I could with this photo, highlight detail was lost from the brightest part of the lighthouse. Fortunately the histogram wasn't too clipped, and ACR's Recovery tool allowed me to pull back some of the lost detail.

Tone curve

Adobe Camera Raw offers two methods of adjusting the tonal curve of your photograph, either of which will allow you to make adjustments to specific parts of the tonal range of your RAW image. The first option, Point, will be familiar to anyone who has used Photoshop, while the second, Parametric, may be less familiar, but is just as easy to understand.

Point curve

The tone curves panel displays a histogram corresponding to the current RAW image. A line runs diagonally across the histogram from top right to bottom left, which represents the changes that can be made to the tonal values in the image. The horizontal axis of the panel represents the original tones in the image—the input value—with the darker tones on the left and the lighter tones on the right. The vertical axis represents the tones after adjustments have been made to the curve—the output value.

When the line is straight, the input and output values are the same and no adjustments have been made. The first diagram (below) shows a point curve with no adjustments made: the vertical input arrow meets the horizontal output arrow from the same point in the image's tonal range. However, if we add a point where the arrows meet and move that point straight upward, the input value stays the same, but the output value increases. You can see this in the second illustration (below right).

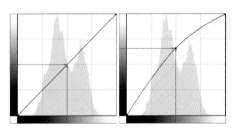

> ### Note
> *By default, the Point curve starts with three points that form a shallow "S" shape (left). This curve brightens the highlight areas and darkens the shadows in an image, increasing the contrast overall.*

The result of this adjustment is that the tones in the image that correspond to the point where the vertical input arrow starts are lightened to the tonal value where the output arrow starts. Pull the point downward, and the output value decreases and the tones are darkened.

With the tone curve set to Point you can add more points to make an increasingly complex curve, enabling you to affect different parts of the tonal range in different ways.

Parametric curve

The Parametric curve tool is slightly different in operation to the Point curve, but the idea of the curve remains the same. On the horizontal axis at the bottom of the tone curves panel are three triangles that split the curve into regions of influence. The sliders underneath these will darken or lighten specific tonal ranges in the image: the *Highlights*, *Lights*, *Darks*, and *Shadows*. When the triangles are furthest apart, the effect of moving the sliders is relatively modest, but when the triangles are closer together the effect on the tonal range of moving the sliders increases.

PARAMETRIC
In the tone curve below left, the areas of influence of the tone control sliders are spread relatively evenly. On the illustration below right, the highlights and shadows in the image will be dramatically affected when the relevant sliders are moved.

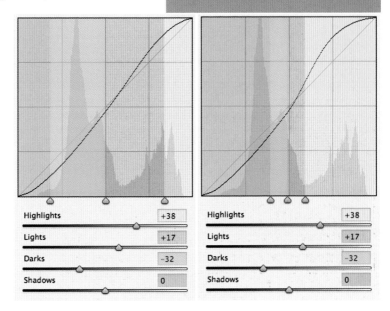

Detail

As the name suggests, the Detail panels allow you to make changes to the fine detail of your image.

Sharpening

When first opened, RAW files can look soft—particularly in comparison with an equivalent JPEG. This is of course because a JPEG has had sharpening algorithms applied to it at the time of capture, whereas a RAW file has had no processing at all.

The act of sharpening an image is slightly misnamed, as the sharpening that is applied is actually an optical illusion. It is achieved by increasing the contrast between edges at the level of a pixel, and the greater the contrast at these edges, the "sharper" the image looks. It is, of course, possible to go too far with sharpening, which can be seen as unnatural halos around elements in the image. Sharpening is generally more visible on a computer screen monitor than it is on a print, but when noticeable it is equally distracting on both.

There are four sliders that are used together to adjust the level of sharpening in ACR, but make sure you are viewing your image at 100% so you can see the changes these make more easily. Pulling the *Amount* slider to the right increases the amount of sharpening in your image, while pulling left decreases it (a value of 0 means no sharpening is applied at all).

Radius adjusts the size of image detail that sharpening is applied to: images with lots of fine

> ### Note
> *Sharpening should be applied on an image-by-image basis depending on the final use of the image. My images are all saved without sharpening applied. If I want to make a print of an image, I first make a temporary copy of it. The amount of sharpening I apply to the image will then depend on the size, the approximate viewing distance of the print, and the paper type.*

Sharpening

Amount	0
Radius	0.5
Detail	0
Masking	0

detail require a smaller radius setting than those with coarser detail.

The *Detail* slider alters how high-frequency information in an image is sharpened. High-frequency images have lots of abrupt tonal changes. The ultimate high-frequency image is one that has black pixels next to white pixels, without any intervening shades of gray. The higher the *Detail* value, the more these tonal changes are emphasized.

Finally, *Masking* sets the level that edges are adjusted. At 0, sharpening is applied globally across the image, but when the slider is set to 100 the sharpening is applied only to distinct edges in the image. Holding down Alt as you drag this slider previews the areas in the image that will be sharpened (these areas are temporarily shown in white) and those that will not (shown in black).

Noise Reduction

Excessive noise can reduce fine detail and cause unwanted color shifts. The *Noise Reduction* sliders allow you to reduce the presence of both luminance and color (or chroma) noise.

There are five sliders for noise reduction. When *Luminance* is set to 0, luminance noise is not reduced, while setting the slider to 100 applies the maximum amount of luminance noise reduction. However, this may make your image appear overly smooth, as fine textural details will also be affected.

Luminance Detail controls the threshold at which luminance noise is reduced, and the higher the value, the more image detail is preserved, but at the cost of a noisier image. A high value of *Luminance Contrast* preserves contrast, but may result in noisier images, while setting a low value will reduce luminance noise, but result in lower image contrast overall.

Color reduces chroma noise in your image. A high value of *Color Detail* preserves thin edges of color, but increases the likelihood of blotchy color. A low value removes these color blotches, but could create color bleeding in your image.

Notes

Because you are affecting the fine details of your image, it is best to adjust the noise sliders with the image magnification set to 100%. This will allow you to see exactly what changes are being made to your photograph.

If any of the noise reduction sliders are ghosted out, click on the ! symbol in the bottom right corner of the window to update the preview.

Noise Reduction

Luminance	0
Luminance Detail	
Luminance Contrast	
Color	25
Color Detail	

Split toning

This is a technique that was developed for traditional black-and-white printing to tint the highlights and shadows in an image with two different colors. You can split tone a color image, but it's recommended that you convert your RAW file to black and white using the HSL/Grayscale tab first.

Once you have done this you can start to tone your image. Dragging the *Hue* slider alters the color with which the image will be toned. You can do this for either the highlights or shadow areas of your image, or both,

as required. Dragging the *Saturation* slider increases the vividness of the tone, while *Balance* alters the dominance of the highlight toning to the shadow toning. At 0, both the highlight and shadow toning is given equal weight; set to a minus value the shadow toning dominates; set to a positive value and it is the highlight toning that is strongest.

The most effective split toning effect comes when two tones that are very different are used. The most common approach is to use a warm tone for the highlights and a cool tone for the shadows. However, photography is all about experimentation and there is no reason not to try different methods for different images.

Camera: Canon EOS 7D
Lens: 17–40mm lens
(at 30mm)
Exposure: 2 sec. at f/16
ISO: 100

SPLIT TONE
The image adjustment options in ACR are numerous enough that you can create a virtually finished image long before it is imported into Photoshop. To create this image, I used the split toning tool to simulate a classic monochrome style.

Lens Correction

The Lens Correction tab will help you to reduce any flaws in your images caused by the limitations of your lenses. There are two ways to make corrections: automatically, if your lens has a profile available to ACR, or manually if it does not.

Manual correction

The manual correction panel is split into three parts: Transform (for the correction of distortion), Chromatic Aberration reduction, and a final option for the removal (or even addition) of Vignetting. Most of the corrections are subtle, so it is often best to work at 100% zoom to see the effect of any changes.

Under Transform, the *Distortion* slider allows you to correct pincushion distortion (when dragged to the left), or you can target barrel distortion (when the slider is dragged to the right). The *Vertical* and *Horizontal* sliders correct for perspective distortion if you have tilted your camera up or down, or left and right, during shooting, while *Rotate* spins your image on its center axis. Finally, *Scale* acts in a similar way to a digital zoom, allowing you to zoom into or out of the image. However, as with any digital zoom, the more you zoom, the greater the loss of detail due to interpolation.

The Chromatic Aberration sliders allow you to cure both *Red/Cyan* and *Blue/Yellow* color fringing. Chromatic aberration is most often seen in areas of an image where there is an abrupt change from light to dark. *Defringe* can be set to *All Edges*, so that chromatic aberration is adjusted on all detectable edges in the image, but this may cause thin gray lines around edges. If it does, select *Highlight Edges* instead, so that the chromatic aberration reduction is only applied to shadow/highlight transitions. Alternatively, switch it *Off* entirely.

Finally, Lens Vignetting can be reduced by applying a positive value to *Amount*, or added by applying a negative value. A low *Midpoint* value moves the vignette toward the center of the image; a high value restricts the adjustment to the edges.

Profile correction

Click on *Enable Lens Profile Corrections* and, if a profile for the lens used to create the image is available, the *Make*, *Model*, and *Profile* pop-up menus should automatically show the correct details. If not, click on the three menus in turn to locate your lens.

> ### Note
> Adobe produces a free application called Lens Profile Creator that enables you to build your own profiles for lenses that are not currently supported by ACR. The app can be downloaded from http://labs.adobe.com/technologies/lensprofile_creator.

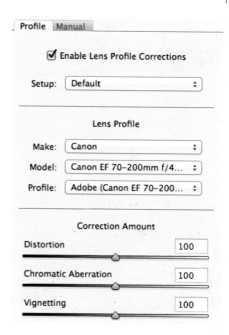

If your lens is not listed, make any adjustments manually, or create your own profile using Adobe's Lens Profile Creator. Use the *Distortion, Chromatic Aberration,* and *Vignetting* sliders to refine your corrections.

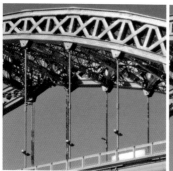
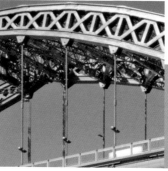

LENS CORRECTION
The image on the left has had no correction; the image on the right was corrected using a lens profile.

Effects

Some photographers feel digital images are "sterile" when compared to film, but ACR's Effects panel helps you bridge this gap.

Grain

The distinctive feature of film is its granular structure. Although digital noise is similar, it has a more regular and arguably less pleasing pattern, so Grain is used to add a random graininess to your images. The *Amount* slider controls how much grain is applied, with *Size* and *Roughness* controlling the character of the grain. The greater the size and roughness, the more the grain will resemble that seen in high ISO film stock. Graininess is particularly effective with black-and-white images, but you should be aware that the more grain you apply, the more fine detail will be obscured.

Post Crop Vignetting

If you have cropped your image, creating a vignette with *Lens Vignetting* via the *Lens Correction* panel will not work. Instead, you need to select *Post Crop Vignetting* from the effects panel.

The *Style* pop-up menu has three options: *Highlight Priority* protects highlight contrast, *Color Priority* preserves colors (to the potential detriment of highlight detail), and *Paint Overlay* creates a subtle vignette effect.

A positive value on the *Amount* slider adds a light vignette around your image and a negative amount adds a darker vignette. A low *Midpoint* value moves the vignetting adjustment toward the center of the image, while a high value restricts the adjustment toward the edges of the frame. *Roundness* controls the shape of the vignette (a negative value creates an oval vignette, a positive value a circular one), and *Feather* determines the softness of the vignette. Finally, *Highlights* controls the strength of the highlights in your image when *Highlight* or *Color Priority* is selected.

Grain

Amount	0

Size

Roughness

Post Crop Vignetting

Style: | Highlight Priority | ⇕ |

Amount	0

Midpoint

Roundness

Feather

Highlights

TIMELESS
Applying a pale vignette with a black-and-white conversion is an easy way to "age" an image. It is possible to go even further, though—by adding grain I could have made the image appear more "film like," and I could have added details such as dust and scratches for greater verisimilitude.

Camera profiles

Every time support for a camera is added to ACR, Adobe also creates the relevant camera profile needed for more accurate color rendering.

Process

Adobe recommends that you use the latest DNG standard available to ACR, which can be chosen

from this pop-up menu. If a ! appears at the bottom left of the image preview window, the image is currently using an older DNG form. Click ! to update.

Camera Profile

What appears in this menu will depend on your camera. What is common to all is the Adobe Standard, which is Adobe's own color profile standard and renders warmer tones well. Other color profiles on this menu will match those found on your camera, such as Landscape or Portrait. These profiles boost or tone down color depending on the intended subject of the image; Landscape will saturate greens to increase the impact of foliage in your images, for example.

Color adjustments

If the standard color profiles don't quite work for you, you can refine them using the color sliders on the Camera Profile panel. These work in a similar way to the sliders found on the HSL/Grayscale panel.

Custom camera profiles

Once you have adjusted the sliders to your satisfaction, you can save your settings as a custom profile so they can be applied to other images. Click on the Raw Settings menu button and select *Save Settings…* When the dialog box is displayed, select *Subset>Camera Calibration* from the pop-up menu and click Save. To apply the preset to other images, click on the Raw Settings menu button, select *Load Settings*, and then locate the .XMP file you saved.

Presets

If you are happy with a particular set of adjustments you have made to an image, ACR allows you to save the settings as a preset that can subsequently be applied to other images.

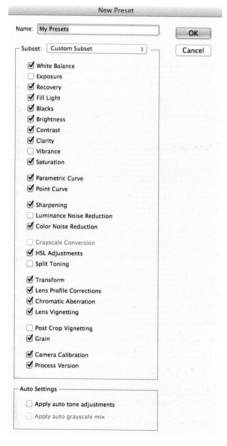

Creating a Preset

Click on the *Presets* button once you have finished changing the settings in the other adjustment panels. Click on the *New Preset* button at the bottom of the Presets panel and, when the dialog box opens, type in a relevant title for your preset. Check all of the settings that you want to save in the preset or choose a particular grouping of settings from the *Subset* pop-up menu and click OK to save the preset or *Cancel* to return to ACR without saving. Once the preset has been created it will appear in the list on the Preset panel.

Applying a Preset

Open a RAW file and click on the *Presets* button. Click on the required preset name from the drop-down list to apply it to the open image. Alternatively, click on the *Raw Settings* menu button, select *Apply Preset,* and choose the required preset from the submenu.

Deleting a Preset

If you no longer need a settings preset, click and drag the preset to the trashcan at the bottom of the Preset panel. When the trashcan turns blue, click once with the mouse button, and the preset will be deleted.

Snapshots

Although you can undo the alterations you make to a RAW file, Snapshot allows you to save a record of any adjustments you've made. This means you can restore an image to a known point any time you need to.

This is useful for a number of reasons. First, it's a good safety net if you want to experiment with your images—if you go too far it is perhaps going to be preferable to return to a point you were satisfied with, rather than to go back and start from the beginning.

Another use is to make multiple versions of the same RAW file. You could make basic adjustments, for example, save a snapshot, and then create a black-and-white version, save a snapshot, and so on.

Creating a Snapshot

Activate the Snapshots tab, then click on the *New Snapshot* button to create a new snapshot. When the dialog box opens, give your snapshot a *Name* and click *OK* to save or *Cancel* to return to ACR without saving. Once the snapshot has been created it will appear in the list on the Snapshot panel.

Applying a Snapshot

Click on the required snapshot in the list to apply it to the open image. Alternatively, click on the *Raw Settings* menu button and select *Apply Snapshot* followed by the required snapshot from the submenu.

Deleting a Snapshot

If you no longer need a snapshot, click and drag it down the list to the trashcan at the bottom of the Snapshot panel. When the trashcan turns blue, click once with the mouse button and the snapshot will be deleted.

Adjusted WB / Contrast
Lens correction applied
Used multiple adjustment brushes

Batch converting

It would be laborious if you had to adjust every image individually from one shoot. Fortunately, ACR allows you to apply the same settings to multiple images at the same time.

When you open several RAW files at the same time, ACR displays the open files as thumbnails in the filmstrip down the left side of the window. Initially, only the first image in the sequence is selected. You can change which image is selected by clicking on its thumbnail, and any changes you make in ACR are only applied to this image.

However, if you select more than one image, the changes you make to ACR's settings will affect all of the selected photographs. To select a number of images hold down Shift at the same time as you click on the image thumbnails—click on a thumbnail again to remove it from the selection. To choose the master image, click on either of the arrows on the right to cycle through the selected images.

If you have only changed the settings of one image, you can synchronize those settings with any or all of the other images. Either select the range of images you want to change or press the *Select All* button above the filmstrip. Once you have done that, press the *Synchronize* button. When the Synchronize dialog box is displayed, select which of the image adjustment settings you want to apply to your images. Clicking on the pop-up menu at the top of the dialog box allows you to select which range of settings to use.

FILMSTRIP
With three images selected.

Trying again

One of the benefits of shooting RAW is that it is possible to revisit old images and convert them differently. Personal technique and tastes develop, as does conversion software. ACR is currently at version 6.5 and tools that were not available when this image was first converted have helped me re-interpret it, in order to produce a more pleasing result.

Camera: Canon EOS 5D
Lens: 50mm lens
Exposure: 1/500 sec. at f/4.5
ISO: 200

Color

Although it is a good discipline to set the white balance correctly at the time of exposure, this is less important when shooting RAW as white balance can be adjusted when it is opened in ACR. There is no loss of image quality in doing this.

Camera: Canon EOS 1Ds MkII
Lens: 17–40mm lens (at 36mm)
Exposure: 2 minutes at f/14
ISO: 100

CHAPTER 6 ADOBE LIGHTROOM

Introduction

The first commercial version of Adobe Lightroom was released in 2007, but the program has been in a state of continuous development and (at the time of writing) is now at version 3.5.

If you use software such as Photoshop to edit a non-RAW image—applying tonal adjustments and so on—the information within the image is gradually and irrevocably altered. If you then save the image and re-open it, it is almost impossible to return it to its original state before the alterations were made. The Lightroom approach is different. The information in an image is not altered at all. As you adjust your images in Lightroom a "recipe" is built up of these adjustments and stored in a Lightroom database known as a Catalog. It is only when you export your image that these adjustments are applied. This means that you can revisit your images at any point, step back through your previous adjustments, and re-interpret them as often as you like, all without any loss of quality. This is known as non-destructive editing.

Of course, when you are editing RAW files, the basic image information in the file is never altered, regardless of the software you use. However, some RAW conversion software will adjust the metadata when alterations are made. If you adjust the white balance, for example, the software may well write this information directly to the RAW file. However, Lightroom doesn't write *any* information to the RAW files; they remain exactly as they were recorded.

As with Adobe Camera Raw, Lightroom has myriad useful features to help you get the best out of your RAW images. There simply isn't the space here to do them all justice, so this chapter will concentrate on two of Lightroom's main modules—Library and Develop. As with most things, the key to getting the most out of Lightroom is practice and experimentation.

POLISHING (*Opposite*)
Lightroom is a powerful tool that well help you to make the most of your images.

Canon EOS 7D with 17–40mm lens (at 19mm), 1/4 sec. at f/16, ISO 100

LOGICAL
Although the Adobe Lightroom layout can appear daunting at first, the approach is logical and easy to grasp.

Working with Lightroom

The adjustments you make to your RAW images in Lightroom are stored in a database known as a catalog. The catalog is also used by Lightroom to keep track of where your RAW files are on your computer hard drive, as well as any metadata associated with those RAW files.

Creating a catalog

The first task is to create a catalog. You don't have to have one catalog for all your RAW files, you can create multiple catalogs as required. I start a new catalog each year so that there aren't too many images in each. If I want to revisit a particular RAW file, I then open the relevant catalog (this is where having a logical file naming convention begins to make perfect sense).

To create a catalog, go to *File>New Catalog*. You will be asked to create a folder for the database. This is not necessarily where your RAW files will be imported to, but it does need to be on a drive with plenty of storage space as it is where Lightroom's LRCAT files are stored. These are the image database files and, as your catalog increases in size, the file size of the LRCAT files increases also. Once you have created a catalog, import your image files.

> **Note**
> *Many of the tools in Lightroom's Develop module are derived from those found in Adobe Camera Raw, which are covered in greater detail in the previous chapter.*

FULL SCREEN
Pressing the Tab key hides and reveals Lightroom's panels.

Modules

Lightroom is split into five modules—Library, Develop, Slideshow, Print, and Web—and each of these is designed for different image-editing tasks. Selecting a particular module simply involves clicking on its name at the top right corner of the Lightroom screen.

Along the bottom of the Lightroom window is a virtual filmstrip that displays all of the images that are currently available to work on. Which photographs are displayed will depend on the images you have in your catalog and whether there are any filters in place that are hiding some of the images from immediate view. Clicking on an image in the filmstrip will allow you to edit that picture in a number of ways, depending on the active module.

The main working area of the Lightroom screen is divided into three sections. On the left of the screen are the panels that show a preview thumbnail of your image, sort your photos into Collections (Library), show the list of alterations applied to an image (Develop), and allow you to apply a variety of Lightroom templates and presets (either those that came with Lightroom or those that you have created yourself). In the center of the screen is the main image display area where you will work on your photograph, and to the right of the screen are the tool panels for the module that is currently in use.

LIGHTROOM 3
The Lightroom workspace with the Develop module active.

Clicking on the triangle in the top right corner of a panel will hide or restore that particular panel as required. If you feel that your Lightroom screen is too cluttered, you can hide the side panels by clicking on the triangles at the edges of the screen. Click on the triangles again to restore the panels, although when they are hidden, moving your mouse pointer to the edge of the screen will also restore them temporarily.

Importing files

To import your images, connect your camera or memory card to your computer. Lightroom will automatically detect that it has been connected and display the Import dialog box. You can either import your images to a new folder on your hard drive, or Lightroom can reference the files in their current location. Of course, as your images are on a memory card this is not a good idea, so importing them to your hard drive is the recommended option. Once the files have been imported they can be edited.

Note

To open a catalog, select File>Open Catalog from Lightroom's main menu. Lightroom can only use one catalog at a time, so the current catalog will close first, but you do not need to save a catalog before launching or creating a new one.

Generally, you would import your images directly from a memory card, but you can also choose to import photographs directly from your computer's hard drive if you have previously copied images there.

Any option on the Import screen that is not checked will not be applied during the import process.

IMPORTING
Once you are familiar with the import process you can choose to reduce the number of options and work using a smaller dialog box.

IMPORT SCREEN

1 Image source selection

2 Toggle check/uncheck selected images: only checked images will be imported

3 Image thumbnail

4 Toggle check/uncheck images

5 Import action (convert to DNG or import proprietary RAW)

6 File handling options

7 Naming options

8 Functions applied during import (such as keywords)

9 **Destination**: Choose the folder on your hard drive that images will be copied to

10 Begin the import process

11 Cancel and return to the main Lightroom screen without importing

12 Change size of thumbnails

13 Change image sorting method

14 Uncheck all images

15 Check all images

16 Loupe view

17 Grid view

18 Toggle between import screen sizes

The Library module

After they have been imported, your images will be displayed in Lightroom's Library module, which is where you can organize and rate your photographs.

How you choose to sort your images is a personal choice, but there will be a tool in the Library module to help you, whatever your preference.

Images can be viewed as a series of thumbnails using the Grid View or as single images using Loupe View. You can then choose the order in which images are displayed by using one of a variety of sorting methods, including by date or using Lightroom's rating system. You can also assign images to Collections, which is a way of grouping images, regardless of how or where they are stored on your hard drive.

The Library is also where you can create and apply keywords to your images, as well as view the EXIF data.

LIBRARY MODULE

1 **Library filter:** Choose the criteria by which images will be displayed

2 **Library Option Panels:** Apply quick adjustments and keyword images

3 **Sync Settings/Sync Metadata:** Synchronize Develop settings between different images or synchronize metadata such as keywords or copyright details

4 **Filmstrip**

5 **Image viewing and navigation tools**

6 **Export image(s)**

7 **Import image(s)**

8 **Publish services:** Add social media site details to export images directly to sites

9 **Folder information:** Details about the folders used to store your RAW files

10 **Collections:** Create a Collection by clicking on the + symbol and following the instructions in the dialog box

11 **Catalog information:** Shows the number of images in the current catalog, the number of images added to a specific collection, and the number of images imported previously

12 **Navigator:** Shows the currently selected image and lets you set the zoom level in the main image window

13 **Main image(s) display area**

Viewing files

Lightroom has a number of tools to help you keep track of your images, allowing you to apply different criteria for sorting and viewing. Those most often used are applied by clicking on the buttons found on the toolbar below the main image display area.

There are four basic ways that images can be viewed in Lightroom:

Grid View All images are displayed as thumbnails. Clicking on a thumbnail makes that image active. You can select multiple images by holding down the Shift key as you click.

Loupe View Displays the active image only.

Compare View Allows you to see two images side by side so they can be evaluated.

Survey View Shows the active photo next to a number of other images—the active image is surrounded by a white border. You can make any of the other images active by clicking on them.

How your images are ordered within the Library is set via the Sort option on the toolbar. You can add more options to the toolbar by clicking on the Toolbar Content button. These options include tools for rotating images. You can also apply flags to mark an image as picked or rejected, or use stars or labels instead. When you export RAW files, the rating and labels you have set will be applied to the image metadata.

1	Grid View	9	Rating
2	Loupe View	10	Labels
3	Compare View	11	Rotate photo left (counter-clockwise)/ Rotate photo right (clockwise)
4	Survey View		
5	Painter	12	Select previous photo/Select next photo
6	Reverse sort order	13	Play slideshow
7	Sort Criteria	14	Resize thumbnails
8	Flag as picked/Flag as rejected	15	Toolbar content

Publishing services

If you regularly post your photos to a social media website such as Flickr or Facebook, you can automate the process of resizing and uploading them with Lightroom's publishing services.

To use this option you must have an account with the social media web site and be prepared to allow Lightroom to access your account. You can also publish directly to your hard drive, which is a good way of automating the process of converting your images into JPEGs for a personal web site or other application.

To use Public Services click on *Set Up...* next to the service you wish to authorize. Work your way down the various options, setting up as many or as few as you require for that service. Click *Save* to save your settings or *Cancel* to return to Lightroom.

If you want to create a service that is not initially listed click on the + symbol on the Publish Services panel and select *Go to Publishing Manager* from the menu. Once there, click *Add* at the bottom left hand corner, then choose the service you wish to create, name the service, and click *Create*.

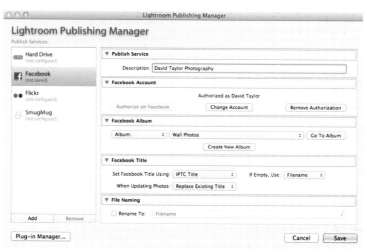

The Library option panels

Histogram

Shows the histogram associated with the current image and the EXIF information stored in its metadata.

Note

Reset All *restores your image back to its original imported state.*

Quick Develop

The Quick Develop panel allows you to make basic tonal adjustments to your images without recourse to the Develop module. This can be done on an individual or group basis, depending on how many images are highlighted. The available options are:

Saved Preset

Lightroom has a number of presets built-in that can be applied to your images. These include a suite of black-and-white conversion options and color film replication. You can also create your own presets for use at a later date.

White Balance

Lightroom can adjust the color temperature of your images, either using standard presets or by increasing or decreasing the color temperature and adding a green or magenta tint.

Tone Control

Select Auto Tone to enable Lightroom to adjust your image automatically. If you want to retain control, decrease or increase the effect of a particular tone control by clicking on the relevant buttons.

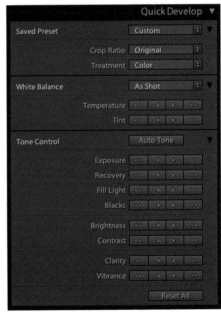

Keywording

There are several methods that you can use to assign keywords to your images. The first is to type relevant keywords into the main keyword box, using either a comma or semi-colon to separate your keywords. Once you've finished, press the Enter key and Lightroom will sort all of the keywords into alphabetical order, deleting any duplicates.

The second method is to type into the keyword entry line below the main keyword box. If Lightroom recognizes part of a keyword as you type, it will display a list of potential matches. If your keyword is on the list you can then click on it and Lightroom will add it to the main keyword box.

If you've added keywords to images before, Lightroom will suggest these keywords if they seem relevant to the image you are currently keywording. If a word in *Keyword Suggestions* is relevant, click on it and it will be added to the main keyword box. The keyword will then disappear from the suggestions list to be replaced by a relevant alternative.

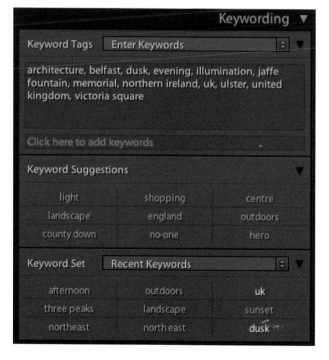

You can also create keyword sets that group associated keywords together. By clicking on the *Keyword Set* drop-down menu you can view or edit keyword sets. When you view a set, the associated keywords are displayed below the menu. Keywords that have not yet been assigned to your image will be ghosted out. When a keyword has been assigned it will be displayed in white.

Keyword List

Every keyword you add to images in your catalog is displayed in the *Keyword List*. If you wish to, you can use the list to quickly see how many images in your catalog use particular keywords. After a while you may find the list excessively long, but it can be filtered: type the whole keyword or part of it into the text entry to narrow the number of keywords displayed in the list.

You can use the keyword list to find images as well: click on a keyword in the list and then on the arrow to the right of the keyword. In Grid view, Lightroom will display all of the images in your catalog that use that keyword.

Metadata

Lightroom can display both EXIF camera data and IPTC metadata, but you can only edit the IPTC data. Which of the IPTC data fields you choose to edit is a personal decision, but it is worth remembering that the more information you add to your images, the easier it will be to search for individual photographs in

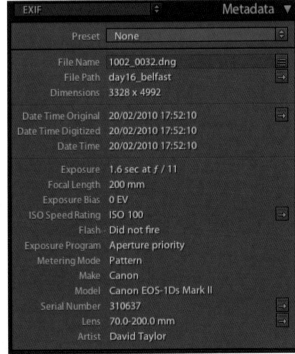

digital asset management software or online. The fields I fill in for every image are the contact fields, as this provides some safeguard against my photography becoming an "orphan" work.

The fields you can edit are shown as darker gray boxes in the Metadata panel. A good example is the *Caption* field, which should be used to describe your image in a comprehensive, yet concise manner. You can choose which metadata fields are shown by choosing an option from the drop-down menu at the top of the metadata panel.

Collections

Creating a Collection is a way of grouping together a series of photos within your catalog so that you can organize or adjust them separately to other images in your catalog. Once you've created a Collection it will be displayed in the Collections panel. There are two ways to create a Collection. A Smart Collection will be created automatically from images that meet a specified criterion. So, for example, you could have a

Smart Collection that gathered together all the images you've awarded a five star rating.

If you want more control over the Collection process, or if the images you want to add don't fall neatly into specific categories, you can create a Regular Collection. Once you've created the Collection you can add images at any point by dragging their thumbnails to the relevant Collection in the list.

You can have as many Smart or Regular Collections as you need. To create either kind, click the + symbol on the Collections panel and select the desired Collection type from the menu. If you are creating a Smart Collection you

will need to specify the rules that an image must follow to be added to the Collection. This is done through a dialog box shown when Smart Collection is selected. To delete a Collection, right-click on the Collection name in the Collection panel and then choose Delete.

Note
You can group your Collections into Collection Sets. The default Smart Collections are already grouped into a Collection Set called Smart Collections.

Develop settings in Library

Your options for adjusting images directly from the Library module are limited, but there are shortcuts that allow you to make quite radical changes to your photographs without opening the Develop module.

When you are in Library you can copy the "recipe" of adjustments from one image to another, for example, and you can also "paint" any of the Develop presets that are available in Lightroom.

To copy settings between images, first select the image you want to copy the settings from. Right-click with the mouse pointer over the image thumbnail. From the menu select *Develop Settings>Copy Settings*. You will now see a dialog box. Select all the adjustment settings that you want to copy and click *Copy*. Now, select the image that you want to copy the settings to (if you select more than one image, the copied settings will be copied to all the images), and right-click again. This time select *Develop Settings>Paste Settings*.

To paint settings, click on the Painter tool in the Toolbar below the main image area. The mouse pointer should now turn into an aerosol can, leaving an empty space where the Painter icon was. Select *Settings* from the menu to the right of where the Painter icon was, and select an adjustment preset from the menu to the right of Settings. Now, when you left-click on any of the image thumbnails, the chosen preset will be applied to those images. When you're finished, left-click in the space where the Painter icon was to exit Painter mode.

SETTINGS
Copying adjustment settings.

Exporting an image

Once a RAW image has been edited you will need to export it as a different file format if you wish to use it for other purposes. Select the image(s) you want to export and click on the *Export...* button. Choose the required options from the Export dialog box and click *Export* to begin the process. Alternatively, click *Cancel* to return to Lightroom.

1. Choose whether you want to export your images to a new folder or use the same folder as your RAW files.

2. Select the new destination folder by clicking on *Choose*. Decide whether you want to add your files to a subfolder.

3. You can choose to alter the file names of the exported images.

4. Select the file format of the exported image and a compression level if relevant. Lightroom can export images in five different formats: PSD (Photoshop's native format); TIFF; JPEG; DNG; Original RAW.

5. Set the size of the file if you want to reduce or increase its resolution. Choose the required pixels per inch/centimeter.

6. Set the output sharpening for your image as required.

7. Apply user-defined metadata to the exported image(s).

8. Add a watermark to your images. This is useful if you are exporting your images for use on a website.

9. Select what happens to the image after exporting, such as opening the exported image(s) in Photoshop immediately.

When I came to process this image I realized that I hadn't used a strong enough ND graduate filter, which made the photograph feel unbalanced. I was able to correct this using Lightroom's Graduated Filter tool set at 0.5 stops.

Camera: Canon EOS 7D
Lens: 70–200mm lens
(at 120mm)
Exposure: 1/2 sec. at f/11
ISO: 100

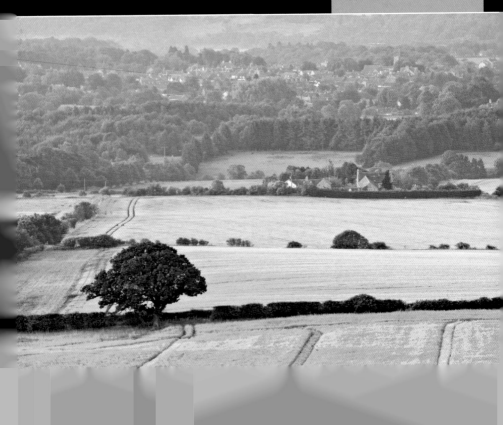

Distortion

Lens distortion is particularly noticeable when you are shooting scenes that contain prominent straight lines. The horizons in seascapes really show how badly or otherwise a lens distorts—water never curves in real life!

Camera: Canon
EOS 5D
Lens: 24mm lens
Exposure: 1/2 sec. at f/14
ISO: 100

The Develop module

The Develop module is Lightroom's "workbench," where the bulk of the adjustments to your images will be made.

As Adobe Camera Raw and Adobe Lightroom share certain technology it's not surprising to find similarities between the two. As with Camera Raw, Lightroom contains essential tools for correcting the color and tonal range of your images, as well as more sophisticated tools such as lens correction adjustments, sharpening, and noise reduction.

Because you never alter the basic RAW file, Develop can also be seen as a laboratory in which to conduct experiments on your images. You can do this in the knowledge that no matter what changes you make, you can undo them at any point. Once you're happy with your images, they can be exported for use in documents or online.

1	**Main image display area**

| 2 | **Develop Option Panels:** The main image-editing tools in the Develop module |

| 3 | **Previous:** Apply previous image's adjustments to current image |

| 4 | **Reset:** Restore image back to settings at import. |

| 5 | **Filmstrip** |

| 6 | **Before and After:** Split the main image display so you can view and compare the image with and without adjustments applied |

| 7 | **Loupe View** |

| 8 + 9 | **Paste and Copy:** Copy settings that have been applied to one image and paste them into another |

| 10 | **Collections** |

| 11 | **History:** As you edit your image you build up a history of the adjustments that were applied. History allows you to step back through these adjustments, all the way to the image's original settings |

| 12 | **Snapshot:** Allows you to save a particular point in the editing process that you can return to quickly |

| 13 | **Presets:** Adobe supplies a number of presets that can be applied to your images, or you can create and save your own, and apply them to other images |

| 14 | **Navigator** |

Before and After

Before and After splits the image editor view screen into two panes so you can see versions of your current image before and after any edits: the Before pane shows the image without any adjustments applied and the After pane shows your image with all the current adjustments applied. If you zoom in or out, or pan around the image in either pane, the other pane will synchronize the view. There are four viewing options available:

Before/After Left/Right

The two views are shown side by side.

Before/After Left/Right Split

The image is split down the middle, with one half showing "before" and the other "after."

Before/After Top/Bottom

The two views are shown one above the other.

Before/After Top/Bottom Split

The image is split across the middle, with one half showing "before" and the other "after."

To return to single image view from any of the Before/After views, click on Loupe View.

The Develop module tools

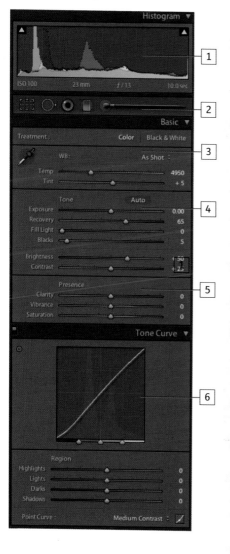

1 **Histogram:** As you make adjustments to your image the histogram will alter to show you how the tonal range has changed. Lightroom's histogram is similar to ACR's, however, in Develop you can drag the histogram left or right to make changes to the tonal distribution.

2 **Tool strip:** Most of the adjustments you make in Develop are applied to the entire image. The tools in the tool strip allow you to make tonal adjustments to specific areas of an image, as well as to crop as required.

3 **White balance:** The white balance setting will initially use that set by your camera. The presets and sliders are the same as those found in ACR.

4 **Tone:** Click on Auto to enable Lightroom to try and calculate the correct tonal range of your image.

5 **Presence:** As with Adobe Camera RAW, Clarity adjusts local contrast, making your image appear sharper, while Vibrance and Saturation adjust the vividness of the colors.

6 **Tone Curve:** Allows you to make adjustments to the tonal range of the image. The default is a Parametric Curve adjustment, but you can click on the small Point Curve icon to change to a Point Curve view. The default is a medium contrast curve.

The Develop module tools *(continued)*

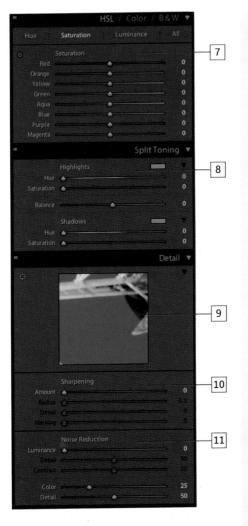

7 **HSL/Color/Grayscale:** This panel allows you to adjust specific colors in your image, from red through to magenta. Pull the sliders to the right to increase the effect, and to the left to decrease the effect. You can choose to view the Hue/Color/ Grayscale panels separately, or all together by clicking on All.

8 **Split Toning:** If you are working in grayscale, split toning allows you to alter the color tint of the highlights and shadows of your image. The two tints can be different, and warm highlights and cool shadows work well together.

9 **Thumbnail view:** Shows the effects of the adjustments you make to your image using the options that follow. Click on the crosshairs to the left of the thumbnail then click within the main image view to select a new thumbnail view. Right-click on the thumbnail to change the zoom factor.

10 **Sharpening:** Sharpening increases the micro-contrast in an image.

11 **Noise Reduction:** Reduces the amount of high ISO noise in an image.

The Develop module tools (continued)

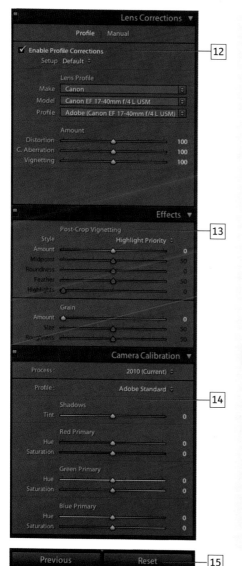

[12] **Lens Corrections:** This works in precisely the same way as Lens Corrections in ACR, and a similar number of built-in lens profiles is available. However, Lightroom does not currently support custom lens profiles made with Adobe's Lens Profile Creator.

[13] **Effects:** Apply effects that can add character to your digital images.

[14] **Camera Calibration:** With this option you can adjust how Lightroom interprets the colors from your camera by selecting the relevant Profile you wish to use from the pop-up menu. The Lightroom default is Adobe Standard, which improves the rendering of warmer colors such as red and yellow. The color sliders allow you to adjust the color tint of the shadows in your image as well as the hue and saturation of the red, green, and blue components.

[15] **Previous, Sync, and Reset:** Click on Previous if you want to apply the settings from the previously adjusted image to the current one. If there is a number of images selected in the filmstrip, Sync replaces Previous. Clicking on Sync will launch a dialog box that allows you to apply some—or all—of the same settings that have been applied to your primary image. Reset returns the image to its original settings. This step is added to the history so you can step back to undo if necessary.

Camera: Canon EOS 7D
Lens: 17–40mm lens
(at 17mm)
Exposure: 1 sec. at f/16
ISO: 100

JUST HOW YOU LIKE IT

The beauty of RAW is being able to refine your vision after capture. Although this photo was shot with a conventional 3:2 format digital SLR, the original shape felt marginally too wide. By cropping in Lightroom, I was able to make the image feel more balanced. Because this change has been achieved non-destructively, I can go back and make further alterations without affecting the image quality.

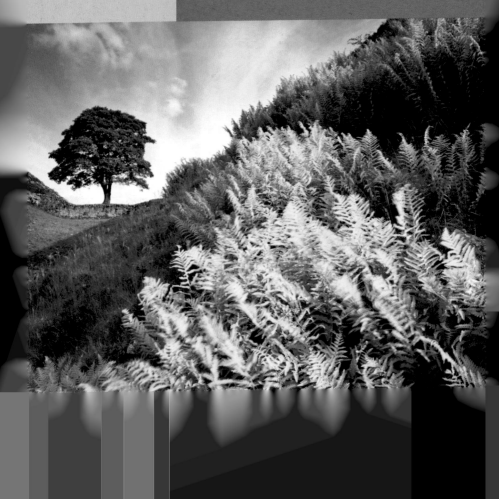

Camera: Canon EOS 7D
Lens: 70–200mm lens
(at 110mm)
Exposure: 1/800 sec. at f/4
ISO: 100

GETTING IT RIGHT

Although I strive to get the exposure right in camera, this is often difficult in changeable, high-contrast situations. With this shot, I exposed this scene to retain as much detail in the shadows as I could, without blowing the highlights in the window frame. Using Lightroom, I then applied the Graduated Filter tool to darken the top window.

The tools

Lightroom's tools allow you to apply adjustments to specific areas of your images. When you click on one of the tools, the available options for it will be displayed below the tool strip.

Crop & Straighten

When you first select *Crop*, a frame is drawn around the edge of your image. Pulling the frame inward by the edges will reduce the size of the frame and everything outside the frame will be cropped. When you are happy with the selection, press Enter (Windows) or Return (Mac) to crop the image.

When *Aspect* is set to *Original*, the crop area will always match the aspect ratio of the original image. Clicking on the pop-up menu displays a list of other aspect ratios such as 1:1 or 4:5. Choosing a different aspect ratio will lock the frame to that shape. If you want to create a less constrained crop frame, click on the padlock

icon. When the padlock is "open," the frame size can be changed horizontally or vertically, independently, without the other being altered.

The *Angle* slider allows you to rotate your image freely around its center point, cropping when necessary to maintain a rectangular image. Clicking on the Spirit Level tool allows you to rotate your image freehand. With the Spirit Level selected, left click and drag within your image. The image will be rotated by the angle created by the start and end position of your mouse click. Checking *Constrain To Warp* prevents your images from becoming distorted if you've also applied a lens correction.

Spot Edit

Thanks to the automatic sensor cleaning systems that are found in many digital cameras, visible dust spots in images are becoming more and more rare. However, at some point you may be faced with the prospect of "dust-busting" and Lightroom's Spot Edit tool will help to make this task, if not pleasant, at least straightforward.

In the same way as ACR, the tool uses two connected circles: the first defines the area that needs repairing and the second circle is the area that will be used as a "patch." With *Clone* selected, the sampled area is replicated exactly, while *Heal* attempts to match the texture, tone, and shading to improve the repair process.

Click on the Spot Edit tool icon to begin using it, and then click on the area you wish to repair. Continuing to hold the mouse button

down, drag the cursor to an area of similar color or detail, and then release the mouse button to make the repair.

The size of the repair circles can be adjusted by moving the *Size* slider. Once the repair circles have been added to your image you can resize them by selecting the repair circle and dragging it in and out to decrease and increase its size. You can also move the patch circle by clicking on it and dragging it to a new location.

If you want to alter the transparency of the repair use the *Opacity* slider. At 100 the tool is completely opaque, at 0 it is completely transparent. To delete an applied spot removal adjustment, select it and then press *Delete*.

Red Eye Correction

Lightroom's Red Eye Correction tool uses the same application method as ACR, as discussed in the previous chapter.

DUST BUSTING
Spots of dust are always more noticeable in clear areas such as sky, and when you have used a small aperture setting.

Graduated Filter tool

As with the Graduated Filter tool in ACR, this tool can be used in a similar way to an ND-Graduated filter to balance the exposure between different areas of an image. To use the tool, select which aspect of your image you want to adjust and then use the slider to alter the level of adjustment. The method of use is slightly different to ACR.

Under the *Effects* pop-up menu is a number of presets for specific tonal adjustment tasks, such as *Whiten Teeth* and *Soften Skin*, but you can also use the sliders outlined below to make custom changes. If you find that you use a certain set of options on a regular basis then you can save them as a preset on the *Effects* menu.

Exposure: Alters the image brightness, mainly affecting the lighter tones.

Brightness: Alters the image brightness, mainly affecting the midtones.

Contrast: Alters the image contrast, mainly affecting the midtones.

Saturation: Alters the vividness of the colors in the image.

Clarity: Adds or removes depth to/from an image by adjusting local contrast.

Sharpness: Increases or decreases edge definition to adjust the apparent sharpness of an image.

Color: Applies a color wash to an area of the image. Click the color picker box to select a color.

To use the graduated filter, click on the icon and set the sliders as desired. Move your mouse pointer over the image and then click and drag to apply the graduated filter. The further you drag, the subtler the filter effect will be.

At the center of the effect is a pin (pin **1** in the screenshot on the page opposite). The three guidelines above (**2**), through (**3**), and below (**4**) the pin show the start, middle, and end of the graduated filter. You can adjust the size of the filter by clicking on either of the two outer guidelines and pulling them closer to each other or further apart.

To rotate the graduate filter effect, move your mouse pointer close to either the left or right side of the pin until it turns into a curved, double-headed arrow. Hold down the left mouse button and move the mouse around until the filter is in the desired orientation.

To move the filter around your image, place your pointer over the center of the pin until it turns into a hand. Hold down the left mouse button and drag to move. If you want to delete an applied graduated filter, select it and then

press the *Delete* key on your keyboard. The pin
of a selected graduated filter has a black center;
an unselected graduated filter has a gray pin.

Adjustment Brush

The Adjustment Brush works in
a similar way to the Graduated
Filter tool, allowing you to alter
selected areas of your image.
Where it differs is that you can
very precisely paint these effects
wherever they are needed. As
with the graduated filter, first
select the preset or slider positions
you want to use, then apply the
brush. This works in the same way
as ACR's Adjustment Brush.

The Slideshow, Print, and Web Modules

There hasn't been space in this book to include information about the remaining three Lightroom modules, but if all you do is edit RAW files, you may find that you never use them.

Slideshow

The Slideshow module allows you to set up a sophisticated and professional-looking image slideshow with the minimum of effort. If you don't want to go to the effort of making your own slideshow you can choose from a number of templates. Or, if you build your own, you can apply any number of effects to your images, including drop-shadows and borders.

To make your slideshow more descriptive, you can also add text. This text can be generated automatically from the image metadata, or you can add personalized text that can be as descriptive as you like. For added sparkle, you can choose how one image fades to the next and you can link the presentation to the music library on your computer.

Print

The Print Module prepares your images for printing. This is achieved through a layout panel on which your image can be resized and rotated. You can also add more than one image—Lightroom works out how to fit multiple images onto a page. As with the Slideshow module, you can also overlay text onto your prints.

SLIDESHOW
Your slideshow could be an exciting extravaganza of visual imagery, or it could be about more mundane subject matter.

PRINT
Preparing an image for printing on A4-sized paper.

If you want to make life easier for yourself you can also use presets for different paper sizes and layouts, or save your own presets once you've created a print presentation style that you like.

If you don't have a printer, you have the option of saving your layout as a JPEG file so it can be printed out on another system or uploaded to an online printing service.

WEB
Creating a subtle web gallery using Lightroom.

Web

Lightroom's Web module takes the pain out of creating web galleries of your images. As with the other modules, there is a number of presets provided by Adobe as a starting point, but you can quickly customize these to your own requirements. Options you can change include choosing the number of image thumbnails for each page of your gallery, the color and style of the gallery, and the type and amount of descriptive text accompanying the images. Once you've built the gallery it can be exported to your computer's hard drive or uploaded directly to your web site using FTP.

The Expanded Guide | **183**

Pushing yourself

How do you get to Carnegie Hall? Practice! It's an old joke, but it's true. The only way to excel at something is to practice, practice, and then practice some more. By practicing your photography as often as you can, not only will your technical skills develop, but your esthetic judgement will mature as well. It's a long and often frustrating road to follow, but one that is incredibly rewarding.

Camera: **Canon EOS 1Ds MkII**
Lens: **70–200mm lens (at 200mm)**
Exposure: **1/30 sec. at f/10**
ISO: **100**

Discipline

Getting the best out of your camera—and RAW—is ultimately about learning good technique and applying it from the point of exposure all the way through to the creation of the final image on your computer screen or print. Processing a RAW file should not be about trying to rescue an image, but a way of drawing out its potential.

Camera: Canon EOS 7D
Lens: 17–40mm lens (at 26mm)
Exposure: 2.5 sec., at f/14
ISO: 100

Glossary

Aberration An imperfection in a photograph, often caused by the optics of a lens.

AE (autoexposure) lock A camera control that locks in the exposure value, allowing a scene to be recomposed prior to the shot being taken.

Angle of view The area of a scene that a lens views, measured in degrees.

Aperture The opening in a camera lens through which light passes to expose the sensor. The relative size of the aperture is denoted by f-stops.

Autofocus (AF) A reliable through-the-lens focusing system that allows accurate focusing without the user manually adjusting the lens.

Bracketing Taking a series of identical pictures, changing only one setting, such as the exposure or white balance.

Buffer A digital camera's built-in memory.

Cable release A device used to trigger the shutter of a tripod-mounted camera at a distance to avoid camera shake.

Calibrator A device used to measure the output of digital imaging equipment. A profile will then be created that can be used by other equipment to keep colors consistent.

Center-weighted metering A metering pattern that determines the exposure of a scene with a bias toward the center of the frame.

Chromatic aberration The inability of a lens to bring all spectrum colors into focus at one point, resulting in color fringing.

Color temperature The color of a light source expressed in degrees Kelvin (K).

Codec A piece of software used to interpret and decode a digital file, such as RAW.

Compression The process by which digital files are reduced in size.

Contrast The range between the highlight and shadow areas of a photo, or a marked difference in illumination between colors or adjacent areas.

Depth of field (DoF) The amount of a photograph that appears acceptably sharp. This is controlled by the aperture: the smaller the aperture, the greater the depth of field.

DPOF Digital Print Order Format.

Diopter Unit expressing the power of a lens.

dpi (dots per inch) Measure of the resolution of a printer or scanner. The more dots per inch, the higher the resolution.

Dynamic range The ratio between the brightest and darkest parts of a scene. Also used to describe a camera sensor's ability to capture a full range of shadows and highlights.

Evaluative metering A metering system where light reflected from several subject areas is

calculated based on algorithms. Also known as Matrix or Multi-segment metering.

Exposure The amount of light allowed to reach the digital sensor, controlled by aperture, shutter speed, and ISO. Also, the act of taking a photograph, as in "making an exposure."

Exposure compensation A control that allows intentional over- or underexposure.

Extension tubes Hollow spacers that fit between a camera body and lens, typically used for close-up work. The tubes increase the focal length of the lens and magnify the subject.

Fill-in flash Flash combined with daylight in an exposure. Used with naturally backlit or harshly side-lit or top-lit subjects to prevent silhouettes forming, or to add extra light to the shadow areas of a well-lit scene.

Filter A piece of colored, or coated, glass or plastic placed in front of the lens.

Focal length The distance (usually given in millimeters) from the optical center of a lens to its focal point.

fps (frames per second) A measure of the time needed for a digital camera to process one photograph and be ready to shoot the next.

f-stop Number assigned to a particular lens aperture. Wide apertures are denoted by small numbers such as f/2, and small apertures by large numbers such as f/22.

HDR High Dynamic Range; a technique to increase the tonal range of a photo by merging several photographs shot with different exposure settings.

Histogram A graph used to represent the distribution of tones in a photograph.

Hotshoe An accessory shoe with electrical contacts that allows synchronization between the camera and a flash unit.

Hotspot A light area with a loss of detail. A common problem in flash photography.

Incident-light reading Meter reading based on the light falling on the subject.

Interpolation A means of increasing the size of a digital photo by adding pixels, thereby increasing its resolution.

ISO (International Organization for Standardization) The sensitivity of the digital sensor measured in terms equivalent to the ISO rating of film.

JPEG (Joint Photographic Experts Group) A compressed file format that uses lossy compression to reduce file sizes to about 5% of their original size.

LCD (Liquid Crystal Display) The flat screen on a digital camera that allows the user to preview and review photographs.

Macro A term used to describe close focusing and the close-focusing ability of a lens.

Megapixel One megapixel = one million pixels.

Memory card A removable storage device for digital cameras.

Mirror lock-up A function that allows the reflex mirror of an SLR camera to be raised and held in the "up" position, before the exposure is made.

Noise Interference visible in a photo caused by stray electrical signals during exposure.

Open-Source Software created by unpaid volunteers that is often free to use.

PictBridge The industry standard for sending information directly from a camera to a printer, without having to connect to a computer.

Pixel Short for "picture element"—the smallest bit of information in a digital photograph.

RAW The file format in which the raw data from the sensor is stored without permanent alteration being made.

Red-eye reduction A system that causes the pupils of a subject to shrink by shining a light prior to taking the picture.

Resolution The number of pixels used to capture or display a photo.

RGB (Red, Green, Blue) Computers and other digital devices understand color information as combinations of red, green, and blue.

Rule of thirds A rule of thumb that places the key elements of a picture at points along imagined lines that divide the frame into thirds, both vertically and horizontally.

Shutter The mechanism that controls the amount of light reaching the sensor.

SLR (Single Lens Reflex) A type of camera that allows the user to view the scene through the lens, using a reflex mirror.

Soft proofing Using software to mimic on screen how an image will look once output to another imaging device. Typically, this will be a printer.

Spot metering A metering system that places importance on the intensity of light reflected by a very small portion of the scene.

Teleconverter A lens that is inserted between the camera body and the main lens, increasing the effective focal length.

Telephoto A lens with a long focal length and a narrow angle of view.

TTL (Through The Lens) A metering (or other) system built into the camera that measures the light passing through the lens.

USB (Universal Serial Bus) A data transfer standard, used by most cameras when connecting to a computer.

White balance A function that allows the correct color balance to be recorded for any given lighting situation.

Wide-angle lens A lens with a short focal length and a wide angle of view.

Useful web sites

GENERAL

Digital Photography Review
Camera and lens review web site
www.dpreview.com

Flickr
Photo sharing web site with a large user base
www.flickr.com

David Taylor
Landscape and travel photography
www.davidtaylorphotography.co.uk

EQUIPMENT

Adobe
Photographic editing software including
Photoshop and Lightroom
www.adobe.com

Apple
Hardware and software manufacturer
www.apple.com

Canon
www.canon.com

Nikon
www.nikon.com

Pentax
www.pentax.com

Sony
www.sony.com

Olympus
www.olympus-global.com

Panasonic
www.panasonic.com

Sigma
www.sigmaphoto.com

PHOTOGRAPHY PUBLICATIONS

Photography books & Expanded
Camera Guides
www.ammonitepress.com

Black & White Photography magazine
Outdoor Photography magazine
www.thegmcgroup.com

Index